FANTASTIC CREATURES

of the

MOUNTAINS AND SEAS

FANTASTIC CREATURES

of the

MOUNTAINS AND SEAS

A CHINESE CLASSIC

TEXT BY
JIANKUN SUN

ILLUSTRATED BY
SIYU CHEN

TRANSLATED AND WITH AN INTRODUCTION BY
HOWARD GOLDBLATT

ARCADE PUBLISHING • NEW YORK

First English-language Edition

Authorized English translation from the Chinese-language edition, entitled
山海经, by 陈丝雨 绘 孙见坤 注 (Shanhaijing or Shan hai jing), published
in China by Tsinghua University Press Limited, 2015

Arcade Publishing books may be purchased in bulk at special discounts
for sales promotion, corporate gifts, fund-raising, or educational purposes.
Special editions can also be created to specifications. For details, contact the
Special Sales Department, Arcade Publishing, 307 West 36th Street, 11th
Floor, New York, NY 10018 or arcade@skyhorsepublishing.com.

Arcade Publishing® is a registered trademark of Skyhorse Publishing, Inc.®,
a Delaware corporation.

Visit our website at www.arcadepub.com.

10 9 8 7 6 5

Library of Congress Cataloging-in-Publication Data is available on file.
Library of Congress Control Number: 2020943858

Editorial consultant: Weihua Liu
Cover design by Erin Seaward-Hiatt
Cover illustration: Siyu Chen

ISBN: 978-1-950691-38-8
Ebook ISBN: 978-1-951627-64-5

Printed in China

All that the earth contains

Within the six directions

And encircled by the four seas

Is illuminated by the sun and the moon

Canopied by the stars and the constellations

Chronicled by the four seasons

Controlled by Jupiter

Those which the gods create

Have their unique shapes

Whether they die young or live long

Only the sages know

Contents

Publisher's Note

Two Young, Unknown Authors Communicating with the Soul of a 4,000-Year-Old Mythical Beast

In China, according to longstanding practice, scholars studying classical culture and paintings are not eligible to publish their work or research results until they are over forty. In fact, the older they are, the easier it is for scholars to be recognized and their work acknowledged.

The illustrator and the author of the modern text for this book are very young. They were born in the 1980s and '90s. When they made this book, the illustrator had just graduated from grad school and the writer was a senior in college. They represent a new generation of young people who love ancient culture. When they started to recreate the ancient Chinese world, they were influenced by modern art and science, showing a different aesthetic from their predecessors.

However, it wasn't easy for them to display their talents.

When I received the first twenty illustrations from Siyu Chen, I was deeply impressed. I wanted to find galleries or an art agency for her. But all the galleries refused her work because she was too young and not at all famous. Despite this response, I couldn't just let such beautiful drawings lie around gathering dust. I decided to publish them, for which I needed Siyu to draw more than a hundred additional pictures, and she agreed immediately. The next thing was to create a text for these illustrations. I felt the best match would be a young scholar of ancient culture.

I searched the internet, where I learned about a "genius ancient culture researcher," Jiankun Sun, who was just twenty years old. Most of the articles I found about Sun didn't praise his talent, but rather questioned it. I was surprised that so many famous scholars would be sharply critical of an article published by a young man. To avoid causing him additional harm, I decided to investigate further before contacting him. Fortunately, the first scholar of ancient culture I asked directly knew him very well. Sun had begun to study such works as *The Classic of Mountains and Seas* (*Shanhaijing*) in middle school and had developed a deep understanding of ancient culture when he was still very young. He had also won first prize in Fudan University's Boya Cup national essay competition for an essay on this classic work. Knowing that he was now in college, I managed to contact him, and he explained to me what was behind his online conflict with the other scholars. Obviously, he had come out of the shadows and was continuing to stick to his studies.

At the same time, Siyu was quietly working on more than one hundred additional illustrations for the book.

They did not disappoint me, let alone their readers.

I wanted to support their efforts, as I should do as a publisher. I wanted to pair these two young Chinese explorers of ancient culture, combine their drawings and text perfectly, and publish an interpretation of ancient Chinese culture that could speak to their contemporaries and everyone fascinated by the mythology, geographies, and lore of our ancestors.

The two young creators of this book grew up facing suspicion and rejections, but they didn't complain. They passed through the vision of the older scholars and traveled all the way back to ancient times. With a special feel for the source and their imaginations, they've managed to express the primordial beasts and mountains and seas in their hearts through the text and drawings that follow. They've allowed the mists of thousands of years to provide a beautiful perspective, so that their peers can find resonance here along with a new motivation to explore.

Introduction

Few works in China's long history have had the enduring appeal of the source for the present volume, *The Classic of Mountains and Seas* (*Shanhaijing*), a mytho-historical compilation that offers a unique glimpse into the country's ancient culture through word and image. Intended primarily as a map of its vast geography, it reveals the people's beliefs, explores cultural myths, and describes many aspects of the natural world. Penned anonymously, though traditionally attributed to Yu, mythical founder of the prehistoric Xia dynasty, its popularity was attested to by the "Peach Blossom" poet Tao Qian, who wrote of it: "Browsing through pictures of mountains and seas, I look up and see the whole universe."

Indeed, compilers of the *Shanhaijing* populated the hundreds of largely mythical mountains and seas with a whole universe of demonic, heroic, and simply bizarre creatures in the written language of the time:

有鸟焉，其状如枭，人面四目而有耳，其名曰颙，其鸣自号也，见则天下大旱.

There is a bird, the form of an owl, a human face, four eyes and ears. It is called Yu, its sound is its name. Its appearance portends drought.

Here is where we shut our eyes and try to conjure up a bird whose face will seem familiar—or at least recognizable—while we must search for a place to put a second pair of eyes and ponder where to add a couple of extra ears. The rest of the bird is a mystery. Does it have a beak or a mouth? What are the feathers like? Could it have fewer than two legs? More? And the call. It cries its own name. The ancient bird says "*yu*," a soft sound, perhaps evoking the melodic *cu-cu-cu-cu* of the cuckoo or the more strident *chickadee-dee-dee* of that tiny fellow. But what to think about that ominous portent of desiccated fields? Does it call to mind a murder of crows, or perhaps blackbirds, which can bring death and malice simply by hanging around your house? But, ah, the owl. Evil incarnate, some would say, witches in some cultures, fiendish spirits in others, stealers of souls in yet others. Whether with two eyes or four, they can see in the dark, and with a head that spins like a poltergeist. With them, drought almost seems like a middling omen.

Shanhaijing has passed through many hands, interpreted, expanded, and explained by scholars and meddlers alike. The earliest versions, we're told, were illustrated, though the images have been lost. Not until the sixteenth century was the work of illustrators preserved for future generations. For most people, those illustrations, rather than the text itself, have become the centerpiece of a sometimes historical, sometimes religious, and,

happily, always captivating classic. Moral precepts, understandably, are in abundance in the textual descriptions, and commentators through the ages have sometimes ascribed moral intent to the work in general, like *Aesop's Fables*, perhaps. But I suspect that its enduring popularity owes more to the curious, epigrammatic nature of the entries and to the accompanying illustrations, which will appeal to those given to asking, "Why not something like this?"

Shanhaijing is infused with the philosophy of Daoist shamans and incorporates many of China's foundation myths and prehistoric figures. Thanks to commentators through the centuries, beginning with Guo Pu, a contemporary of Tao Qian, we encounter the Yellow Emperor; the great kings of pre-dynastic China—Yao, Shun, and Yu—the First Emperor Qin Shihuang; Chang'e the moon goddess; the archer Houyi, who shot down nine of ten suns; Kuafu, who tried to run down the last one; and Nüwa, considered to be the mother goddess of Chinese mythology. There are princes and scoundrels, heroes and villains, consorts and shrews. We see lizards and snakes, rodents and goats, birds and bees. And, of course, a menagerie of dragons. All with as many bizarre physical attributes and grotesque features as one can imagine. We are witness to suicides and murders, pleas to heaven, and castings to hell. Something for everyone, you might say.

Likely completed in the Han dynasty, during the first two centuries of the modern era, the finished work consists of four parts, describing "mountains" (*Shanjing* 山經), "seas" (*Haijing* 海經), "the great wilderness" (*Dahuangjing* 大荒經), and "lands," China itself (*Haineijing* 海內經). The first five sections include creatures from the Southern, Western, Northern, Eastern, and Central Mountains. The second half consists of four chapters each of Lands Beyond the Seas, Lands Within the Seas, the Wasteland, and a final Lands Within the Seas. In all, 550 mountains and 300 rivers are recorded, with more than 250 animals and as many as 450 gods and deities.

The current volume, *Fantastic Creatures of the Mountains and Seas*, includes 133 entries, text selected by the young expert Jiankun Sun, who supplies an expanded version in modern Chinese and who writes that "the illustrations are the soul of the *Shanhaijing*," here created by the brilliant artist Siyu Chen. With an emphasis on aesthetic beauty and evocative detail, the illustrations and their descriptions present for the reader a timeless view of an ancient society, both the real and the imaginative.

The Chinese source for the commentaries in *Fantastic Creatures of the Mountains and Seas* was a twelfth-century woodblock edition of *Shanhaijing*, to which supplemental geographical material has been supplied by Qixiang Tan, a twentieth-century geographer. Professor Richard E. Strassberg's *A Chinese Bestiary* is an invaluable resource for those wishing to learn more about the *Shanhaijing*.

In his *The Book of Imaginary Beings*, Jorge Luis Borges, the Argentine giant of world literature, has taken pains to lead his reader from "the zoo of reality to the zoo of mythologies, to the zoo whose denizens are not lions but sphinxes and griffons and centaurs," monsters that are "no more than a combination of parts of real beings." Borges throws a light on "the strange creatures conceived through time and space by the human imagination."

The limits of the human imagination have never been measured, and none have been attempted here. What the writers of Chinese antiquity pictured when they penned their skeletal descriptions of what they believed, we're told, were real creatures seen on trips to the far-flung corners of the known world. What you will encounter in these pages might well be in true correspondence with your own creative vision, but they might not. It's up to you. Enjoy the journey!

A Note on the Translation

Modern pinyin spellings have been used throughout. Names of creatures that are meaningfully translatable have been translated; the others have not. A few Chinese words have not been translated, to avoid duplication, most prominently the words "shan" for mountain and "shui" for river. Prehistoric rulers were kings; the first emperor was, as we know, the founder of the Qin dynasty two centuries before the modern era. Titles like the Yellow Emperor and Flame Emperor have, however, been retained for their familiarity.

H. G.

Mountains Classic
山 经

The Southern Mountains
南山经

Lushu 鹿蜀

有兽焉，其状如马而白首，
其文如虎而赤尾，其音如谣，
其名曰鹿蜀，佩之宜子孙。

In ancient times, a mystical animal known as the Lushu lived on Niuyang shan near what is now the city of Lianzhou in Guangdong Province. A horse it was, and yet it wasn't. The head, like most of its body, was white as snow—the symbol of death in some cultures, of freedom in others—while its tail, like its hooves, was a fiery, auspicious red. But what truly distinguished the Lushu were irregular tigerlike streaks that seemed to drip down its sides from the ridge of its back. Said to have the melodic voice of a balladeer, it was hunted nearly to extinction, for wearing a piece of its pelt guaranteed a legacy of many sons and grandsons. To the ancient Chinese, who placed extreme value on family lineage, it was indeed a marvelous creature. Legend has it that during the reign of the last emperor of the Ming, a single Lushu was sighted in southern Fujian Province. None was ever seen again.

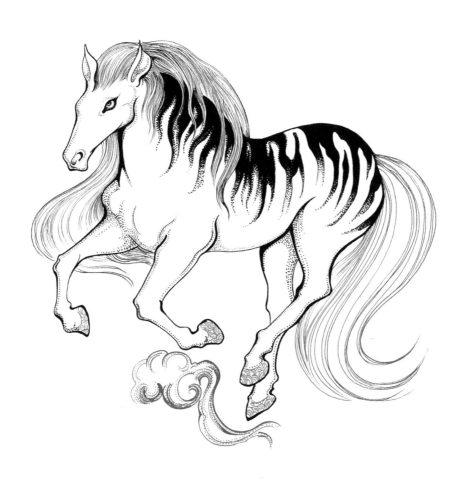

Xuangui 旋龟

怪水出焉，而东流注于宪翼之水。其中多玄龟，其状如龟
而鸟首虺尾，其名曰旋龟，其音如判木，佩之不聋，可以为
底。

The Guai shui, whose headwaters are in Niuyang shan, flows
east to empty into the Xianyi River. According to legend, it was
once home to a strange, some would say hideous, creature that
had the disorienting appearance of a common black turtle but
the head of a bird, the tail of a venomous snake, and a call like
wood splitting. The legend continues with the surprising note
that wearing a piece of the turtle prevented deafness and was
especially effective in removing calluses.

Disastrous floods occurred during the waning years of
King Shun's reign. The father of King Yu was ordered to find a
way to prevent them, but could think of no means to contain
the persistent floodwaters. One day, as he was strolling by a
river, he spotted a rare Xuangui, whose head was on one end of
the massive mound of a shell, the tail on the other. King Shun
struck upon the concept of levees to keep the rising waters at
bay. We know by now that levees are ineffective in preventing
floods, and for his failure King Shun was put to death. When
his son, the great King Yu, assumed his father's mission to enact
flood control, a Xuangui arrived unbidden and, along with
a Yellow Dragon, came to Yu's aid. Millennia later, scholars
recorded this extraordinary incident, which was passed down
orally over the years: "A yellow dragon dragged its tail ahead of
a mud-scooping Xuangui." More than preventing deafness and
removing calluses, this selfless deed deified the turtle.

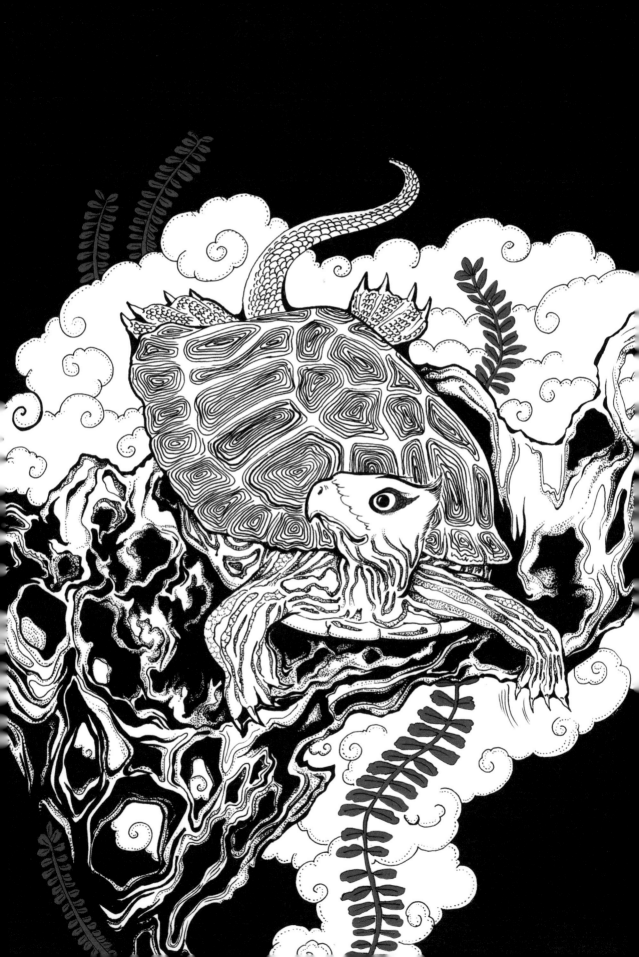

Lu 鲑

有鱼焉，其状如牛，陵居，蛇尾有翼，
其羽在鲑下，其音如留牛，其名曰鲑，
冬死而夏生，食之无肿疾。

Few ancient animals were a stranger mix than the Lu, a water
creature found on Zhi shan, some three hundred li east of
Niuyang shan. The Lu had the horned head and bellowing
voice of an ox, the tail of a reptile, and a bird's wings that grew
out from its rib cage. Its fins appeared underdeveloped, which
left propulsion to the undulating motion of the reptilian tail.
Later generations claimed that the creature had four vestigial
cloven hooves, though they appear to have been lost. Legend
has it that the Lu hibernated through the winter, not awakening
from its sleep until summer. Eating its flesh was known to cure
swelling and ease the accompanying pain.

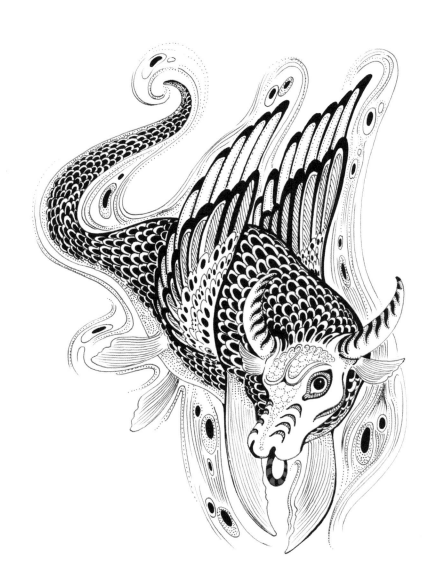

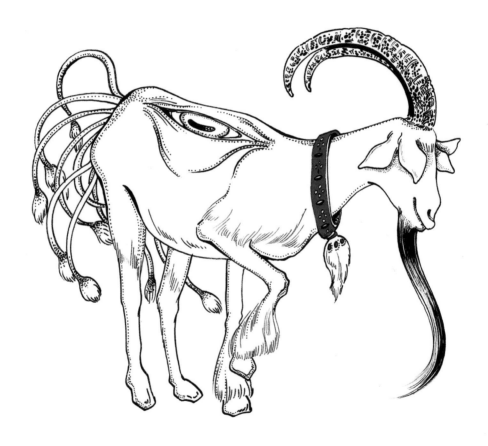

Boyi 猼訑

有兽焉，其状如羊，九尾四耳，其目在背，其名曰猼訑，佩之不畏。

The Boyi was a bizarre goatlike creature that roamed the ledges of Ji shan, three hundred li east of Zhi shan. This sure-footed mountain denizen had nine tails, four ears, and a pair of eyes strangely situated on either side of the backbone. How it negotiated treacherously narrow pathways high on the mountain remains a puzzle. Despite the docile appearance of the Boyi, a portion of its pelt worn at the waist allowed the wearer to gallop fearlessly and confidently through the world. The bravery and ferocity thus attained was in marked contrast to the animal's compliant appearance, a seeming contradiction that immortalized this singular creature.

Changfu 鸧 鸼

有鸟焉，其状如鸡而三首六目、六足三翼，其名曰鸧鸼，
食之无卧。

In the skies above Ji shan's crags and precipices, over which
the Boyi roamed, a peculiar bird called the Changfu released
three-note screeches as it hurtled through the air. The odd
avian resembled a chicken, but one with three heads, three
pairs of eyes, three pairs of legs, and three wings. Unlike a
bird's, its single tail curved, functioning as a counterbalance
to its forward-leaning body. There is evidence that the body,
with its trinity of physical features, was at the core of religious
beliefs of an ancient race of people. Local residents who were
willing to brave the dangers of climbing Ji shan hunted the
Changfu for a medicinal stimulant found in its flesh that
lessened or even eliminated the desire and the need to sleep.

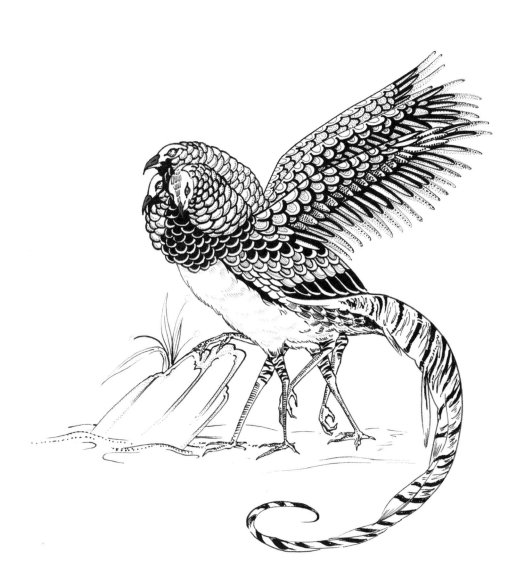

Jiuwei hu 九尾狐

有兽焉，其状如狐而九尾，其音如婴儿，
能食人；食者不蛊。

Deep in the bowels of Qingqiu shan, another 300 li east of Ji shan, lived the fabled Jiuwei hu. It looked like an ordinary fox but sported nine extravagant tails. Its call of a whimpering infant could be fatally deceptive, for this animal was a man-eater. When the tables were turned and the eater became the eaten, the meat was prized for medicinal properties that inhibited the effects of toxic insect bites and, it was believed, prevented evil spirits from possessing the eater's body, in much the same way that later generations of Taoists employed magic talismans and charms. Folklore proclaimed that any person who sighted a pristine white nine-tailed fox would ascend the throne. According to legend, when the Great Yu was out for a stroll on Tu shan, he actually spotted a white nine-tailed fox and in fact became king. Depictions of the creature appeared on ceramics from the Western Zhou period and later joined toads and three-legged crows in images of the Queen Mother of the West. From uncanny animal to propitious symbol, it gained immortality through ascetic practices and was consecrated to live on the magical Kunlun shan.

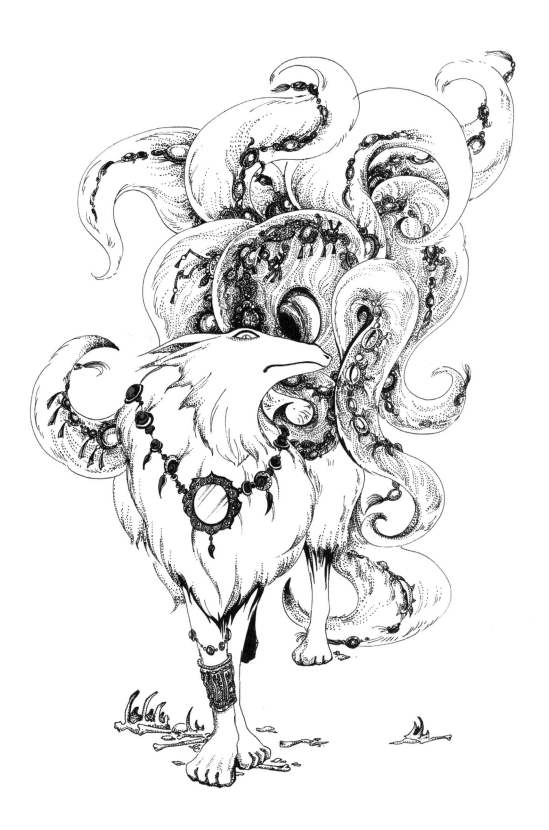

Chiru 赤鱬

英水出焉，南流注于即翼之泽。
其中多赤鱬，其状如鱼而人面，
其音如鸳鸯，食之不疥。

A fish called the Chiru populated the clear waters of the Ying River, which started its southward flow on Qingqiu shan and emptied into the Jiyi marshland. It swam just below the surface, its trim, shiny body and a multitude of elongated, almost feathery fins barely visible behind a head on which the face of a beautiful woman attracted fishermen and voyeurs alike. For some, the effect was spoiled by the harsh quack of a mandarin duck. When it was taken out of the water, its face returned to its fishy origins, gills appeared on the cheeks, and once-shiny scales lost their luster. The Chiru's disagreeable taste was compensated for by its power to cure scabies.

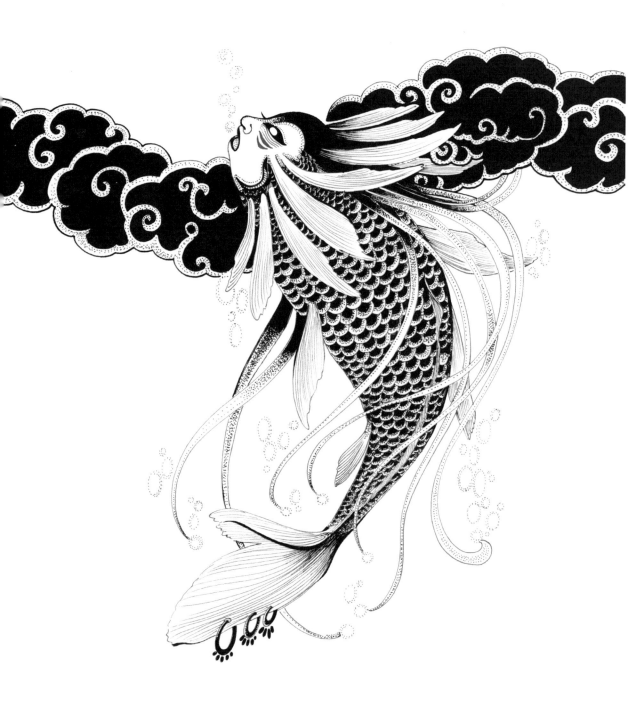

Zhu 鴸

有鸟焉，其状如鸱而人手，其音如痹，
其名曰鴸，其名自号也，见则其县多放士。

The Zhu bird lived somewhere northwest of current-day
Changde, in Hubei Province, on Gui shan. Closely resembling
a sparrow hawk, the Zhu had human hands and slender fingers
in place of talons. All day long its call of *zhu zhu zhu* filled the
sky, as if it were calling out to itself. In popular legend, this bird
was said to be the transmigrated form of Dan Zhu, the son
of Yao. The king chose Shun as his successor over Dan Zhu,
a spoiled, stubborn son, whom he then exiled to the south
as a minor duke. Outraged by the decision, Dan Zhu joined
forces with a Sanmiao tribal chieftain to launch a renegade
offensive. When the rebellion was put down, a defeated Dan
Zhu threw himself into the ocean. After death, his unreconciled
soul assumed the shape of a Zhu bird. Wherever this odd bird
appeared, local virtuous officials were sent away, some into
exile. With all the noblemen absent, petty men ran rampant.
Some have called this Dan Zhu's revenge.

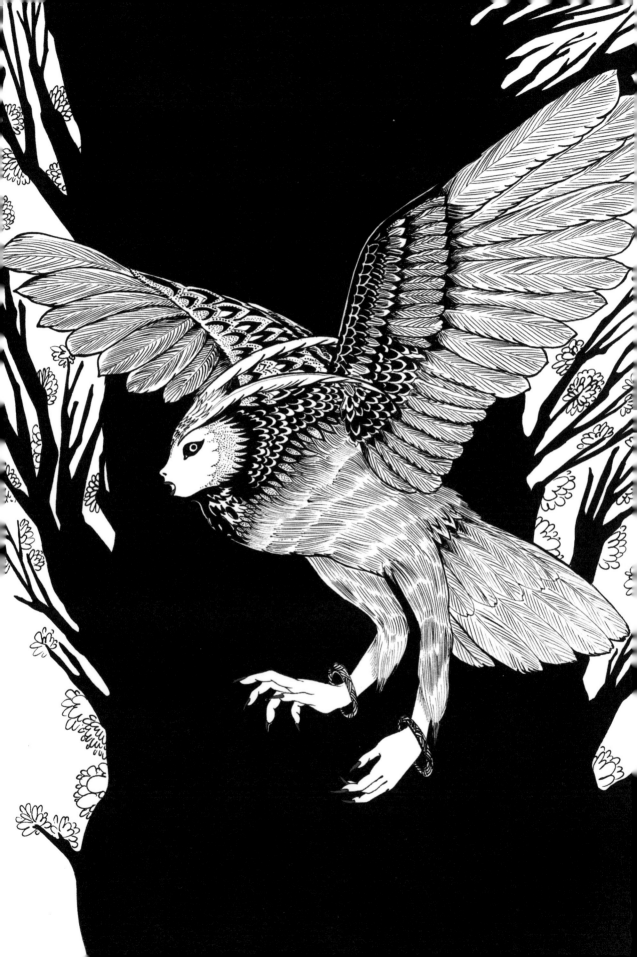

Huahuai 猾褢

有兽焉，其状如人而彘鬣，穴居而冬蛰，
其名曰猾褢，其音如斫木，见则县有大繇。

Traveling some four hundred fifty li southeast of Gui shan,
one reached Changyou shan. Another mountain, Yaoguang
shan, stood three hundred forty li due south and was home
to a curious creature known as the Huahuai. It had the body
of a tree-dwelling mammal and was covered from head to
toe with pig bristles that were braided and festooned with
foraged gemstones. Spending most of its life in a cave, where
it hibernated in winter, it had a staccato call that sounded like
chopping down trees. Once awakened, it moved at a slothlike
pace. In times of peace, when the Tao prevailed under heaven,
it stilled its voice and went into hiding. Its reappearance
portended the occurrence of large-scale violence, a time when
local men were taken on as conscripts for impending warfare.

Gudiao 蛊 雕

水有兽焉，名曰蛊雕，其状如雕而有角，
其音如婴儿之音，是食人。

Six thousand li east of Yaoguang shan, one arrived at Luwu
shan, a barren mountain where not a blade of grass grew,
though it was rich in valuable ores. It was the source of
the Zegeng River, which flowed east and emptied into the
Pang River, where lived a strange man-eating creature that
resembled, but was not, an ordinary bird. A horned vulture,
the Gudiao had a richly feathered body, a serpentine tail, and a
head with a hooked beak and a single horn from which several
pointed ends bent backward. Like the nine-tailed fox, it feasted
on human flesh and had the fetching cry of a whimpering
infant. This cry drew victims into its trap to become its next
meal.

Fenghuang 凤凰

有鸟焉，其状如鸡，五采而文，名曰凤皇，首文曰德，翼文曰义，背文曰礼，膺文曰仁，腹文曰信。是鸟也，饮食自然，自歌自舞，见则天下安宁。

The Fenghuang, known as the phoenix, was the king of the 360 species of birds. It had the look of a golden pheasant, with feathers that dazzled the eye. Of the five elements, its green head represented wood, its white neck metal, its red back fire, its black chest water, and its yellow feet earth. Its feathers were patterned to represent written characters: on its head a 德 for "virtue"; on each of its wings a 义, for "righteousness"; on its back a 礼 for "courtesy"; on its chest a 仁 for "benevolence"; and on its belly a 信 for "trust." When the four virtues of benevolence, righteousness, courtesy, and trust were displayed on its body, and with its every auspicious appearance, the world was at peace. Historically, there were both male (feng) and female (huang) entities, but the female predominated and is now linked to the mythical dragon. No wonder it is considered the most important bird in Chinese civilization.

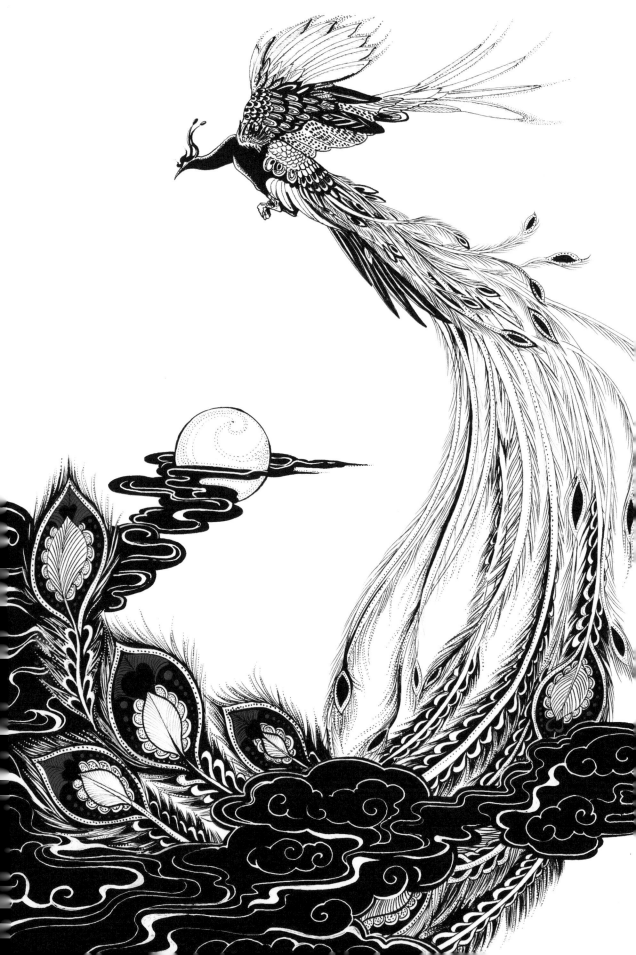

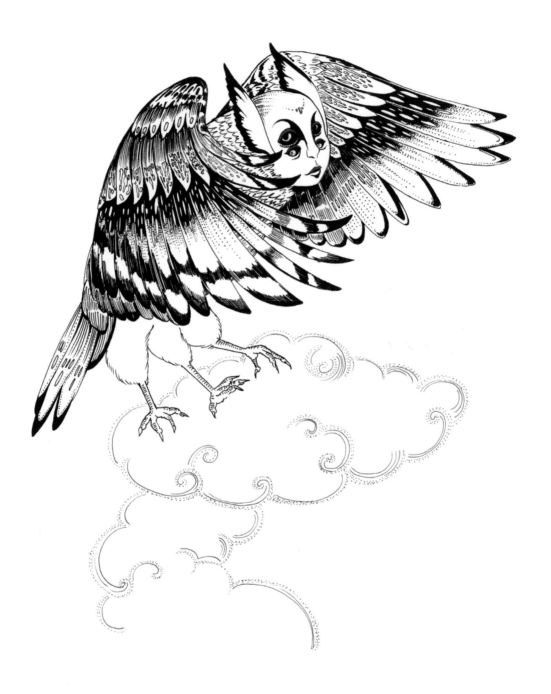

Yu 颙

有鸟焉，其状如枭，人面四目而有耳，其名曰颙，其鸣自号也，见则天下大旱。

The facial beauty of the ancient Yu belied the savage nature of an avian hybrid that terrorized the air above the barren Lingqiu shan, some 2,700 li south of Danzuan shan. Unquenchable fires made the mountain inhospitable for land dwellers. The Yu's form closely resembled that of a ferocious owl of legend that killed and would eat its own mother. Two sets of eyes and human ears drew the gaze away from three menacing feet with razor-sharp claws. Whenever it appeared in the sky with its distinctive *yu yu yu* call, as if naming itself, droughts were sure to follow. In the twentieth year of the rein of the Ming Wanli Emperor, it is said, one of these birds, two feet or more in height, was sighted above the Chengning monastery in Yuzhang. As feared, a severe drought baked the land for the whole summer, leaving a harvest of parched stalks and dead seeds.

Longshen renmian shen 龙身人面神

凡南次三经之首，自天虞之山以至南禺之山，凡一十
四山，六千五百三十里。其神皆龙身而人面。其祠皆
一白狗祈，糈用稌。

Dragons have assumed many animal forms over the
millennia, residing in mountains and streams. They have
been deified and occasionally demonized, though they are
widely revered as providers of protection and symbols of
plenty in China. Those that lived in one of three mystical
ranges of the Southern Mountains roamed an area
containing fourteen mountains that stretched 6,500 li, from
Lushan all the way to Nanli shan. Unlike denizens of the
other two ranges, which had dragon heads atop bird bodies
or bird heads on dragon bodies, these mountain gods had
footed serpentine bodies and faces of a somewhat hideous
nature. Worship of the human-faced dragons required
the sacrifice of a white dog and an offering of the finest
polished rice.

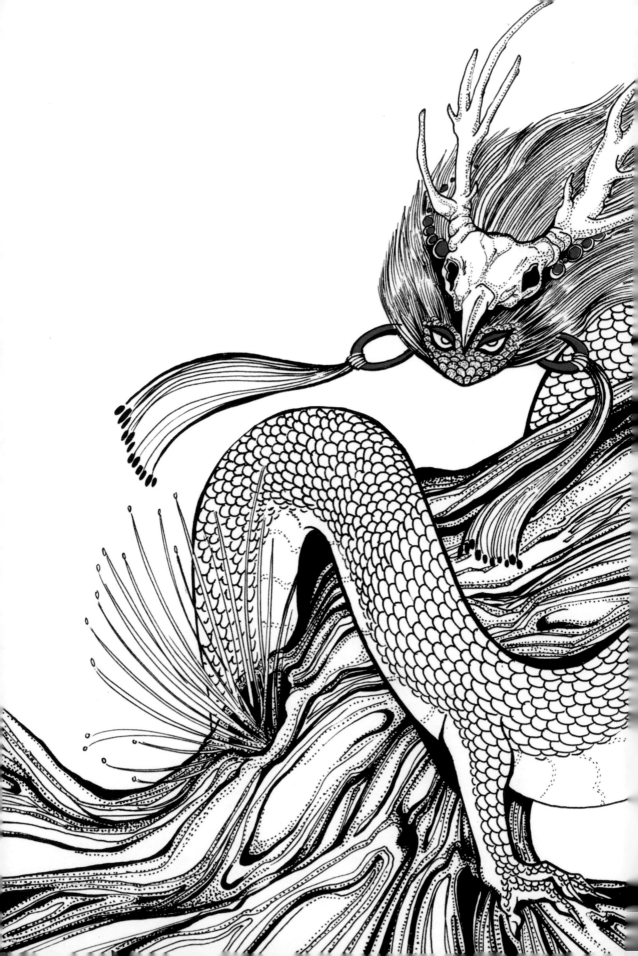

The Western
Mountains

西山经

Feiwei 肥蟥

有蛇焉，名曰肥蟥，六足四翼，
见则天下大旱。

Snakes have no feet; they slither. The ancient Feiwei, however, had six feet. They were augmented by four small wings clustered just behind its ferocious head. How the strange apparition moved remains a mystery, but at each miraculous advent on Taihua shan, now known as Yuehua shan, severe drought fell upon the land below. Legend has it that during the reign of King Tang, founder of the Shang dynasty, this oddly hybridized creature appeared on or above Yang shan and brought forth seven years of calamitous drought. In Southern Mountains, we were introduced to the Yu bird, whose appearance foreshadowed severe droughts that lasted three months, a mere fraction of the severity brought about by the Feiwei—a case of a minor fiend in the presence of a major one.

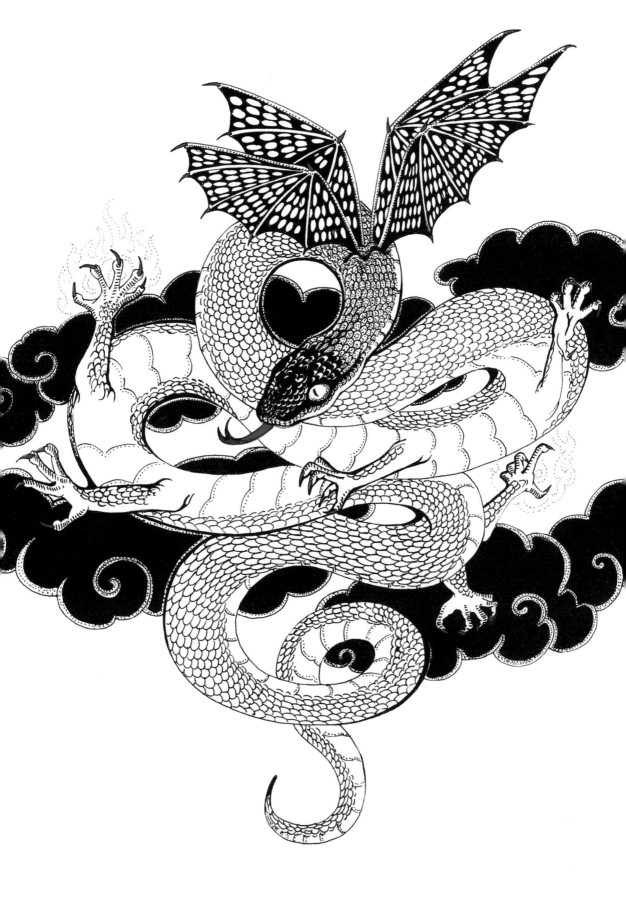

Conglong 葱聋

其兽多葱聋，其状如羊而赤鬣。

Deep in the remote past, Fuyu shan, a mountain rich in natural resources, existed in the southwest corner of today's Huayang city in Shaanxi Province. Copper was mined on the southern slopes, iron on the north. The fruit of a tree called the wenjing, which grew in profusion, was a known cure for deafness. Beyond that, eating a weed familiarly called ginger grass insured increased mental acuity. This sacred mountain was home to a wild creature with the unusual name of Conglong—"onion deafness"—a bighorn sheep with incredible leaping ability whose distinguishing feature was a ruff that turned uncommonly bright at times, as if dyed by the berries of the ginger grass. Its horns were a valued commodity, but obtaining them required a mountaineer who had both keen skills with a bow and arrow and nerves of steel.

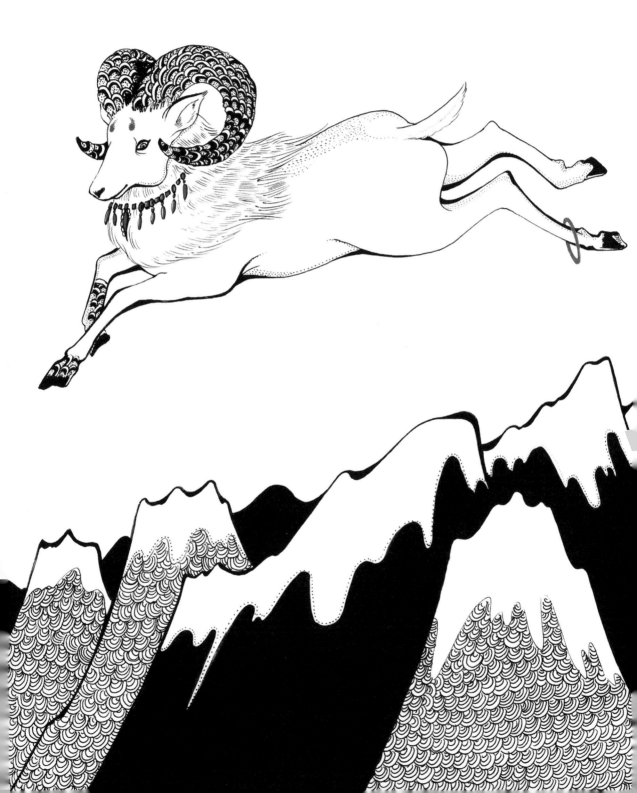

Min 䳇

其鸟多䳇，其状如翠而赤喙，可以御火。

Fuyu shan was also the nesting place for a marvelous bird known as the Min. Its red beak and clusters of red feathers on the tip of its tail were all that distinguished it from the common kingfisher. People fortunate enough to have caught one and kept it at home were assured of fire protection, a boon for those ancients who lived in houses made mainly of wood. Its call, either in the wild or in cages, has never been described, though unlike the thin whistle of a kingfisher, it was likely something louder and more urgent to warn of fire. Killing and eating a Min was taboo for obvious reasons.

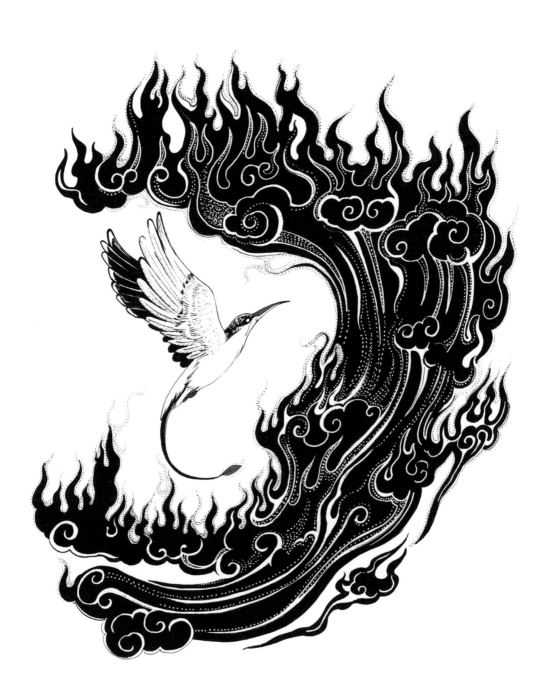

Xiao 嚣

有兽焉，其状如禺而长臂，
善投，其名曰嚣。

The headwaters of the Qi River were somewhere
on mythical Yuci shan, in what is now the Linyou
County region of Shaanxi Province. Copper mines
were said to dot the northern slope, while exquisite
Yingheng jade was mined on the opposite side of
the mountain. A strange apparition lived on both
sides of Yuci shan, an apelike tree dweller called the
Xiao, whose powerful long arms allowed it to fend
off predators by hurling objects. Its unerring aim
kept animals and humans at bay. Its name, implying
clamor, could indicate that it made its presence
known with loud screeches.

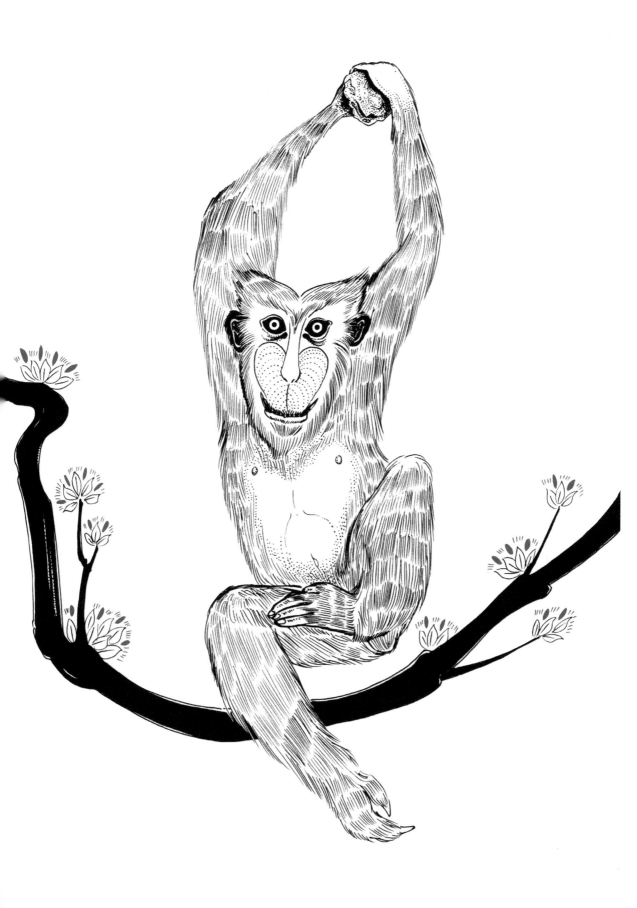

Xibian 谿边

有兽焉，其状如狗，名曰谿边，
席其皮者不蛊。

A mountain is intimidating by its nature, but there was one whose name, Lord of Heaven, inspired awe and trepidation. Of course, you would not find a Lord of Heaven anywhere on the mountain, though many varieties of trees and plants flourished there. Eating one species of otherworldly grass known as wild ginger made horses run faster and shrank tumors in humans. This was the domain of the Xibian, a canine capable of climbing trees. Sleeping on the pelt of one kept away venomous insects and evil spirits. It was such an elusive creature that even the Duke of Qin had no luck capturing one, and was reduced to slaughtering any large dog that bore a resemblance in an attempt to keep insects at the city gate at bay. Somehow, this preposterous ruse worked, setting the stage for the killing of dogs and spilling of their blood to ward off unwelcome events, a practice passed down through the ages. This convention served people as a means of ridding ghosts from their lives, all in the name of an uncommon canine that could not be caught.

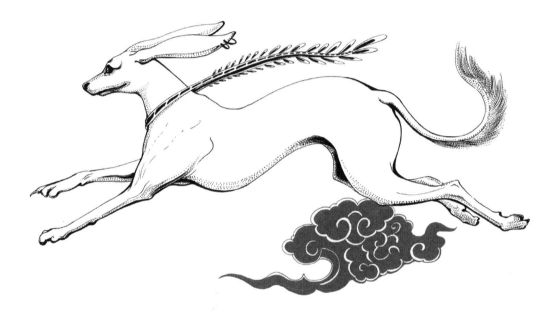

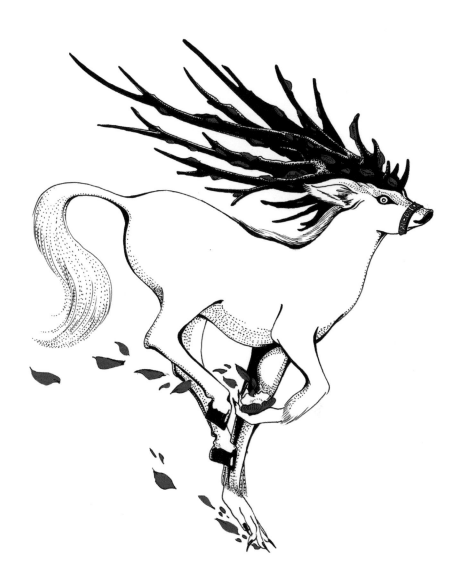

Yingru 嬰如

有兽焉，其状如鹿而白尾，马足人手而四角，名曰婴如。

Leaving Lord of Heaven, one must travel nearly four hundred li before reaching the headwaters of two rivers, the Qiang and the Tu, on Gaotu shan, a densely forested mountain with laurel trees. The mining of silver and gold proceeded alongside that of mispickel, an arsenic sulfide used in herbal medicines and rat poison. Running wild through the forest was a stately, fleet-footed, white-tailed deer called the Yingru, whose tail more closely resembled a horse's and whose front legs ended in human hands with long, tapered fingers, while uncloven hooves tipped the rear legs. Even more striking was what can only be called a headdress, consisting of four distinct horns with many pointed offshoots. Like horned animals everywhere, it was a favorite target of hunters, though its speed usually kept it safe.

Min 犫

又西百八十里，曰黄山，无草木，
多竹箭。盼水出焉，西流注于赤水，
其中多玉。有兽焉，其状如牛，
而苍黑大目，其名曰犫。

Huang shan—not the famous mountain
of today but one with the same name—
stood a hundred and eighty li west
of Gaotu shan and was devoid of all
flora except bamboo, which grew in
profusion and swayed gracefully in daily
breezes. High in the mountain, the river
Pan began its western flow to the Chi
River, sending pieces of jade coursing
noisily along the way. Observing from
the bamboo groves was a fierce, black-
pelted bovine called the Min, smaller
than today's oxen. Its size enabled it to
weave its way through dense stands of
bamboo, while its curved horns and
large, piercing eyes kept predators at bay.

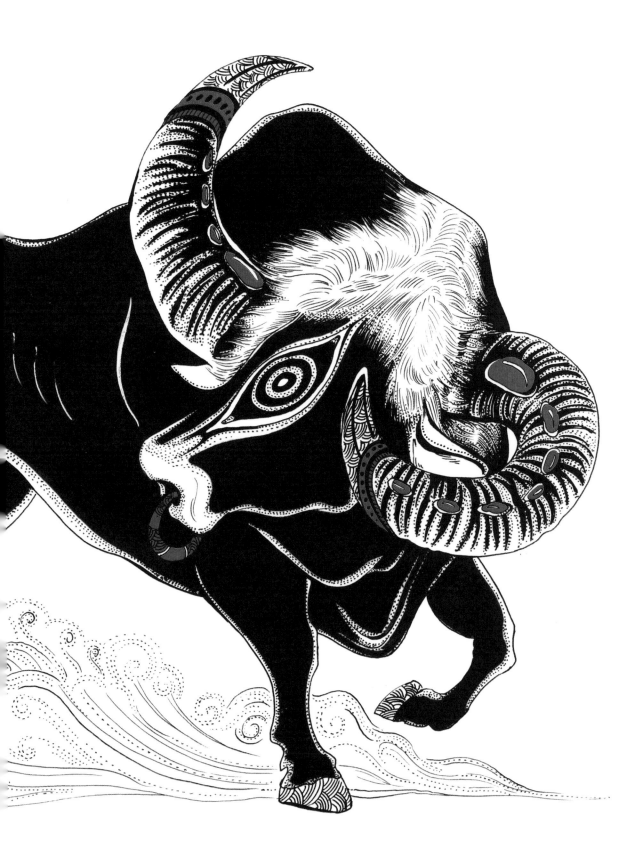

Luan 鸾鸟

有鸟焉，其状如翟而五采文，
名曰鸾鸟，见则天下安宁。

The provocatively named Nüchuang—Woman's Bed—shan
once stood somewhere south of Shaanxi Province's Longxian,
its dense forests home to a fabulous phoenix-related bird
known as the Luan. Resembling a pheasant but with dazzling
magenta-tipped feathers, its most notable feature appears to
have been its voice, which produced a crisp sound like the
peal of a struck bell, but modulated in the five ancient musical
tones. Everything about the Luan proclaimed propitious tidings
and, like the phoenix, brought peace and goodwill wherever its
flight took it.

When the Duke of Zhou suppressed the Wu Geng
Rebellion, he reclaimed the throne and extended his territory
through a victory in the Eastern Expedition. As he was about to
relinquish the throne to his nephew, a Luan flew over the Zhou
capital of Gaojing from the west. What followed was the reign
of Chengkang, when the world was at peace and punishments
were not used for more than forty years.

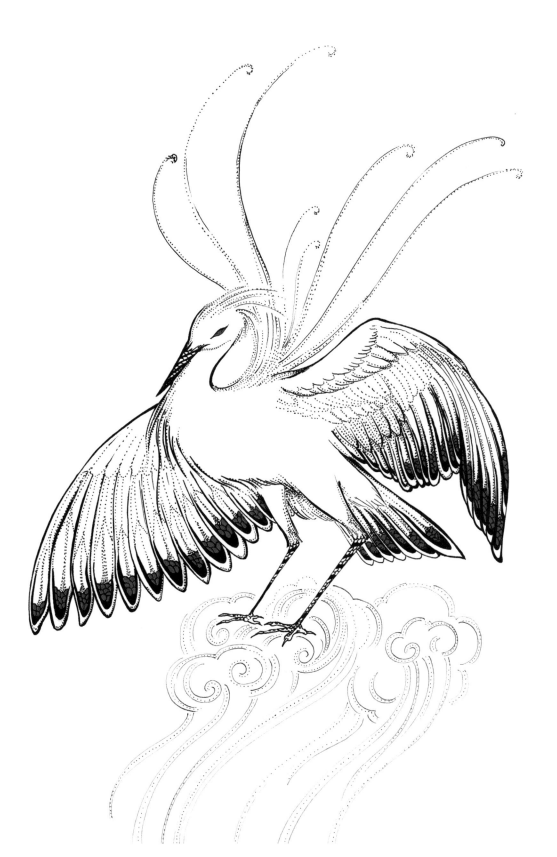

Wenyao 文鳐

是多文鳐鱼，状如鲤鱼，鱼身而鸟翼，
苍文而白首赤喙，常行西海，游于东海，
以夜飞。其音如鸾鸡，其味酸甘，食之已狂，
见则天下大穰。

"Fish out of water" perfectly describes the Wenyao, at least half the time. The rare sightings of this unique creature, endowed with both fins and feathers, occurred near Taiqi shan in present-day Gansu Province in the far west. Dwelling in the headwaters of the Guan River, the carplike Wenyao, whose scarlet lips accented its foot-long white body and dark green scales, lived in the Western Sea during the day and traveled in schools through the air to the Eastern Sea at night, returning at dawn. The vast distances seemed to take no visible toll on the otherwise aquatic Wenyao.

According to Dongfang Suo of the Han, not all returned from their daily flight; some settled in a lake in the far reaches of the Eastern Sea, where they grew to a length of eight feet or more. Even those were seldom seen by humans, but when they were, bountiful harvests followed. Their meat was said to be sour with a slightly sweet aftertaste. The Qin dynasty's encyclopedic *Master Lü's Spring and Autumn Annals* cites the Wenyao as having a taste to satisfy the gourmet and the potential to cure insanity. These qualities limited the proliferation of this harmless creature.

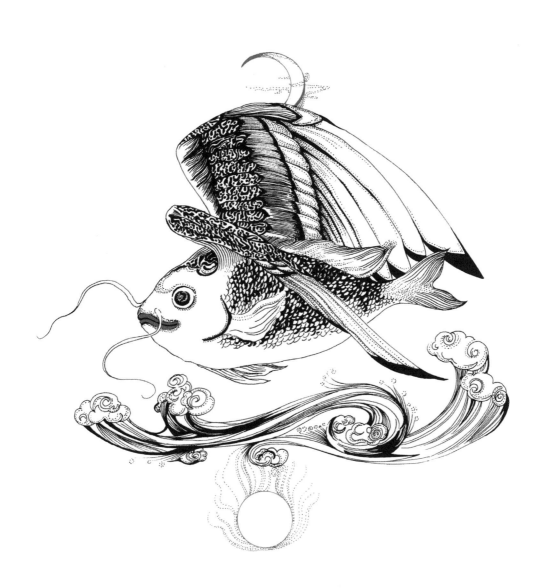

实惟帝之平圃，神英招司之，其状马身而人面，
虎文而鸟翼，徇于四海，其音如榴。

There was, legend has it, an earthly garden created
by the Lord of Heaven on Huaijiang shan, three
hundred and twenty li west of Taiqi shan. A
supernatural being called a Yingshao tended the
garden. With an equine body and irregular feline
markings down its sides, it had a humanoid face
and a pair of feathered appendages on a neck
covered by curly black hair. Though the Yingshao
was in charge of the garden, it did not spend all its
time there, choosing to spread its wings and soar
the skies of the wide world, its long tail flaring
out behind it. It was likely disseminating the Lord
of Heaven's latest mandates, yet it was reputed to
possess a surprisingly harsh voice, sounding more
like a creaky winch than a welcoming call from on
high.

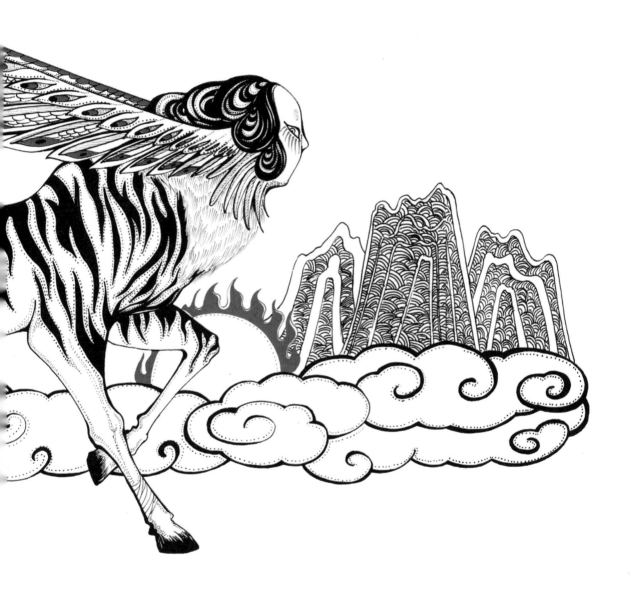

Tulou 土螻

有兽焉，其状如羊而四角，名曰土螻，是食人。

Kunlun shan, the Lord of Heaven's second earthly
capital, lay four hundred li west of Huaijiang shan.
It was home to many strange animals, one of
which was the Tulou, definitely not one of the mole
crickets, as the "lou" of its name implies. If you
sought a goat with two pairs of horns, talons on
its front feet, and a terrible disposition, you would
find it in this vicious killing machine. Any human
or animal this beast attacked would die on the spot,
none spared. Piles of bones marked its passage
across mountain slopes.

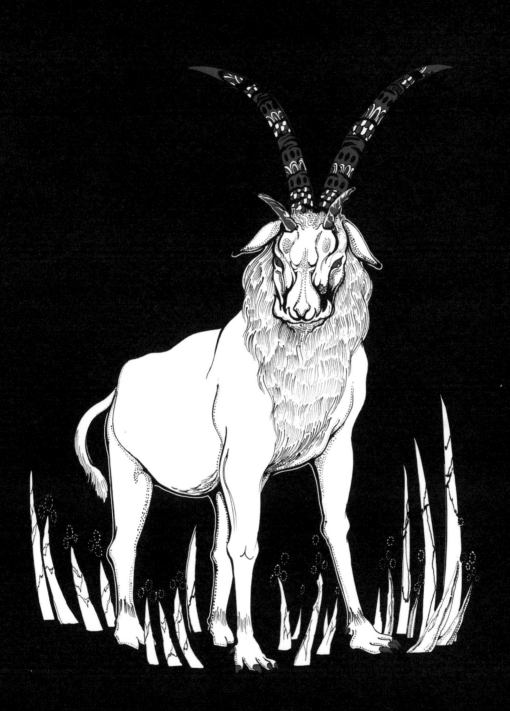

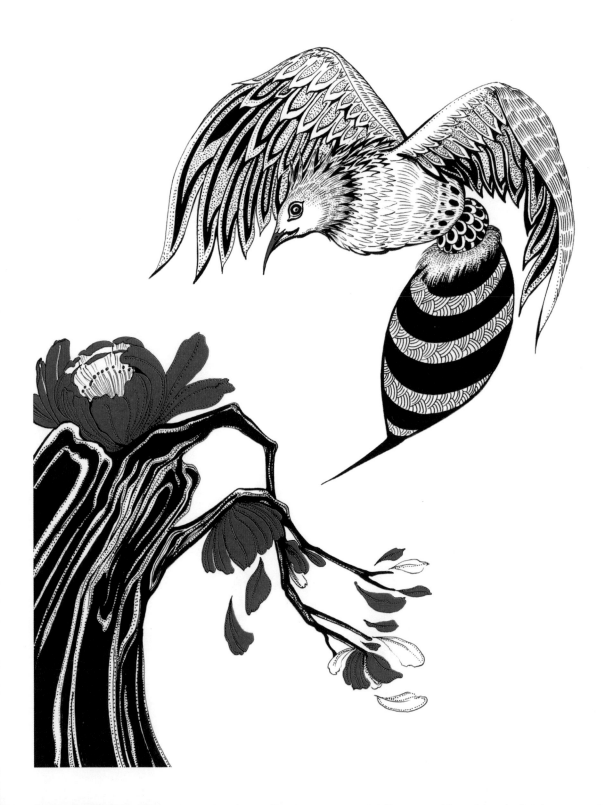

Qinyuan 钦 原

有鸟焉，其状如蜂，大如鸳鸯，名曰钦原，蠚鸟兽则死，
蠚木则枯。

Another of Kunlun shan's denizens was a bird that injected
poison into its prey. The size of a mandarin duck, but with an
articulated body like a wasp, the Qinyuan had large wings that
projected the illusion of far greater size. Any bird or animal it
attacked, including one as large and ferocious as Kunlun shan's
Tulou, died within seconds of being stung. Even flowers and
weeds were not exempt from the Qinyuan's deadly poison; a
mere few drops made them wither and die. The undersized
predator was a more formidable hunter than the Tulou. Despite
or perhaps because of its association with the Lord of Heaven,
Kunlun shan's plethora of uniquely savage creatures defied
expectations. It was a forbidding mountain.

Xiwangmu 西王母

又西三百五十里，曰玉山，是西王母所居也。西王母其状
如人，豹尾虎齿而善啸，蓬发戴胜，是司天之厉及五残。

Yu shan, known as Jade Mountain, 1,300 li west of Kunlun
shan, was the home of Xiwangmu, Queen Mother of
the West, a spectacularly arresting—some would say
mesmerizing—creature. Not the actual beautiful woman
of legend, this "Queen Mother," while possessing the upper
form of a woman, had a leopard's tail, a tiger's fangs behind
seductive lips, and the howl of a wild animal. Her tangled
hair was held in place by jade ornaments. Charged with
arranging calamities, pestilences, and punishments among
earthlings, she functioned like an ominous constellation.
While not manifestly unattractive, the nontraditional, almost
feral beauty of this daunting creature exuded an inauspicious
aura, owing to the dreadful events under her charge. In late
stories, King Mu, fifth ruler of the Zhou, visited Xiwangmu
and enjoyed an intimate encounter, but if he had seen her
like this, he would not likely have chosen to dally with her. It
assuredly would have proved disastrous.

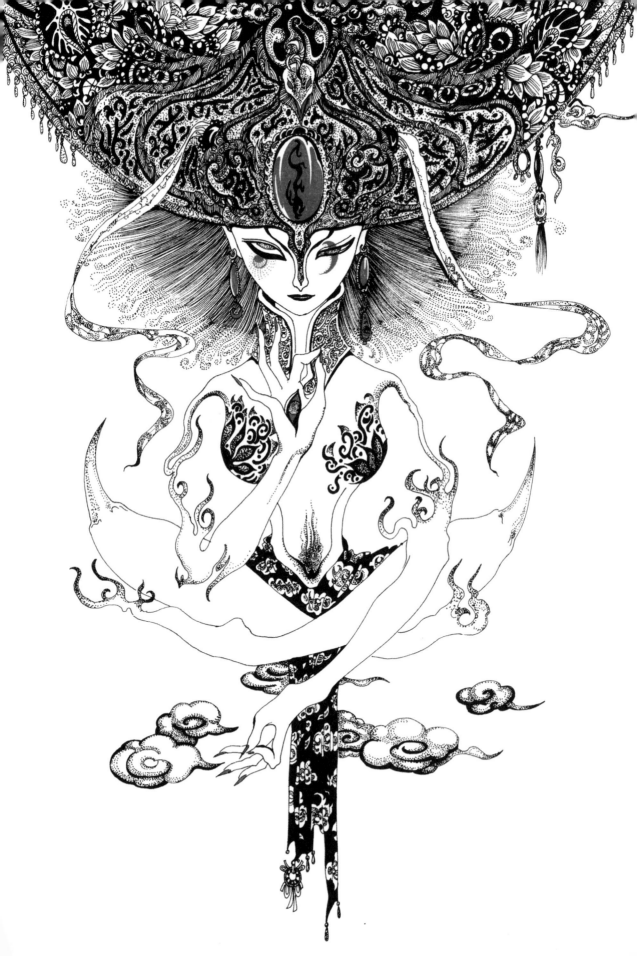

Jiao 狡

有兽焉，其状如犬而豹文，其角如牛，其名曰狡，
其音如吠犬，见则其国大穰。

The Jiao, a creature that brought good tidings wherever it
roamed on Jade Mountain alongside Queen Mother of the
West, was a large canine with spots on the fringes of a thick
coat. Sleek as a racing hound, it had long, backward-pointing
horns. Despite its loud and menacing bark, bountiful harvests
throughout the country followed the rare appearance of a Jiao,
which was why it was considered by those who worked the land
to be a great, if rare, symbol of prosperity.

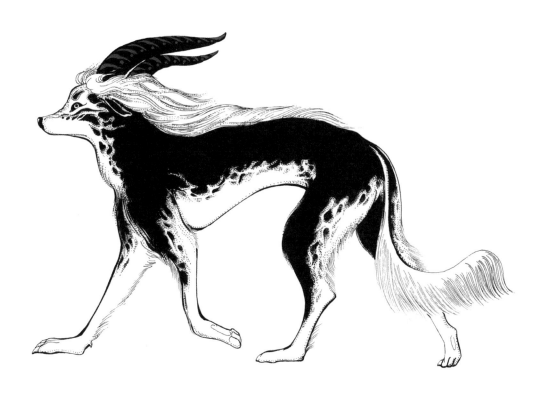

Baidi Shaohao 白帝少昊

其神白帝少昊居之。其兽皆文尾，
其鸟皆文首。是多文玉石。

Baidi Shaohao, a figure associated with one of the ancient kings
of legend, was thought to have lived on Changliu shan, nearly
a thousand li west of Jade Mountain. All the wild creatures
that inhabited this remarkable mountain shared a visible
characteristic: florid bodily designs. The animals sported
decorative tails, the birds had patterned heads, and even
the jade taken out of the ground had markings that made it
especially desirable and valuable. The aura of Baidi Shaohao's
bejeweled attire and long-flowing braided hair typified the
physical beauty of peaceful Changliu shan.

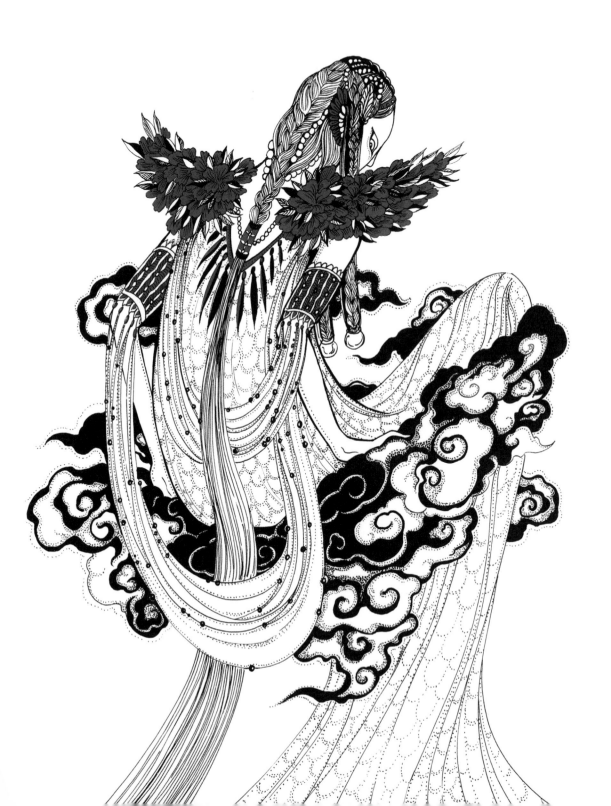

Dijiang 帝江

有神焉，其状如黄囊，赤如丹火，六足四翼，
浑敦无面目，是识歌舞，实惟帝江也。

One of the oddest creatures imaginable lived on mythical
Tian shan, a peak that shared the name of a famous peak in
present-day Xinjiang. Dijiang, also known as the Hundun,
a chaotic state in which it existed, was headless and faceless,
an amorphous leathery sack in appearance, but one with
six legs (each ending in three nailed toes) and four fiery
red wings. Despite its hideous appearance, Dijiang could
dance and sing, and might well have been the god of dance
and song. Zhuangzi once related this parable: Shu was ruler
of the south, Hu was ruler of the north, and Hundun was
ruler of the center. Shu and Hu often met in Hundun's land,
where they received royal treatment. When they desired to
repay his generosity, they thought that, since Hundun had
no features, they should create them by drilling seven facial
openings—eyes, ears, nostrils, mouth—one each day, into
its body. They finished their work on the seventh day, and
on that day Hundun died.

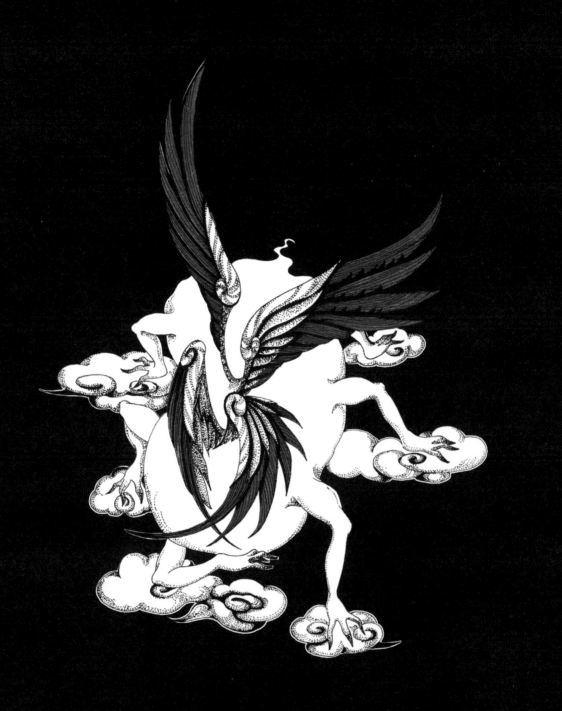

Huan 讙

有兽焉，其状如狸，一目而三尾，名曰讙，其音如夺 百声，
是可以御凶，服之已瘅。

Barren Yiwang shan, nearly four hundred li west of Tian shan, had
rich lodes of gold and jade. Its rocky ledges were traversed by an
odd creature called the Huan, a one-eyed, three-tailed feline that
was said to be a superb mimic. It was reputed by some to have the
ability to imitate the calls of a hundred animals, while other sources
claim that it roamed its territory repeating the same call—*duobai,
duobai*, meaning "I mimic a hundred sounds"—day in and day out.
No definitive evidence has ever been found to substantiate claims
that this truly remarkable creature possessed the power to ward
off demons and evil spirits, and that eating its flesh was a cure for
jaundice. No use was found for the tails.

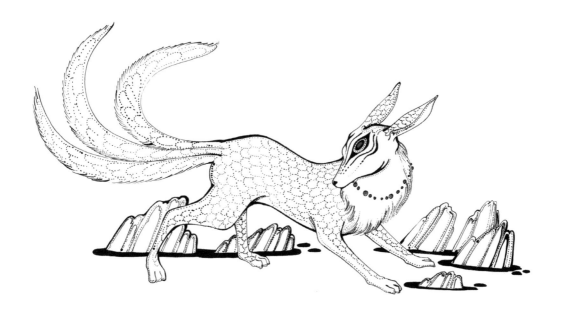

Yangshen renmian shan shen 羊身人面山神

凡西次三经之首，崇吾之山至于翼望之山，
凡二十三山，六千七百四十四里。其神状皆羊身
人面。其祠之礼，用一吉玉瘗，糈用稷米。

Four mountain ranges comprise the total of the Western
Mountains. The third range stretched from Chongwu shan all
the way to Yiwang shan, a total of 6,744 li, with twenty-three
mountain peaks. All the immortal animals on these mountains,
male and female, were goatlike creatures with scowling faces.
Worshippers of these legendary beasts were required to
bury a lucky piece of patterned jade in the ground and make
offerings of sinica rice. Ancient peoples burned offerings to
heavenly deities, sending them skyward in puffs of smoke. If
they celebrated earthly or mountain deities, they buried their
offerings in the ground. The same logic applied to river deities,
whose offerings were flung into the water.

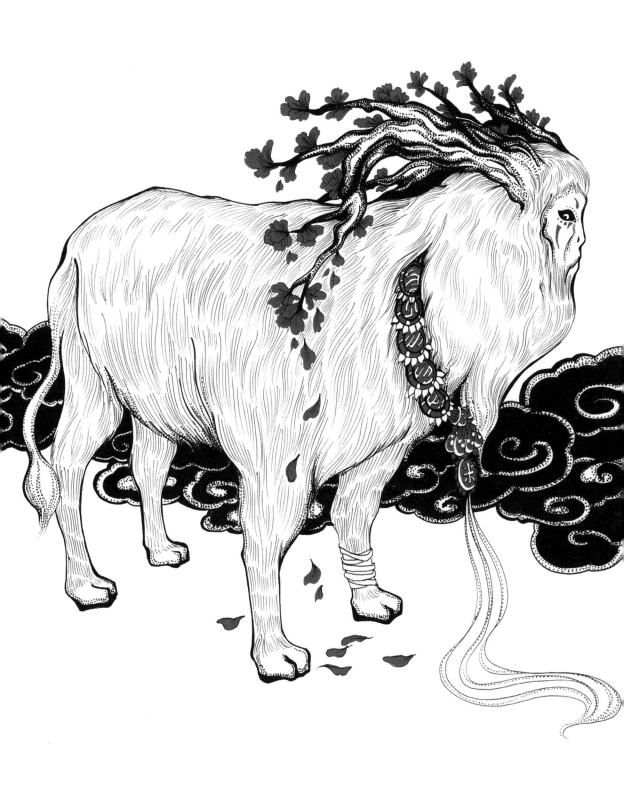

Shenchi 神魂

是多神魂，其状人面兽身，一足一手，其音如钦。

Far back in the remote past, Gang shan rose skyward
in the southwest corner of present-day Tianshui city
in Gansu Province. It was home to an odd humanoid
called Shenchi, which some have mistakenly
proclaimed to be a local mountain spirit. It was, in
reality, a fetching simian creature with a human face
and an animal's torso. It had only one arm and one
leg, on opposite sides of an upright body. Its cry,
hardly more than a sigh or a moan, was like a sad
commentary on its deformed body. Rain stopped
falling as it moved from tree to tree, a power that may
have compensated for the absence of symmetrical
limbs. Its passage through the forest canopy was
lopsided and perilous.

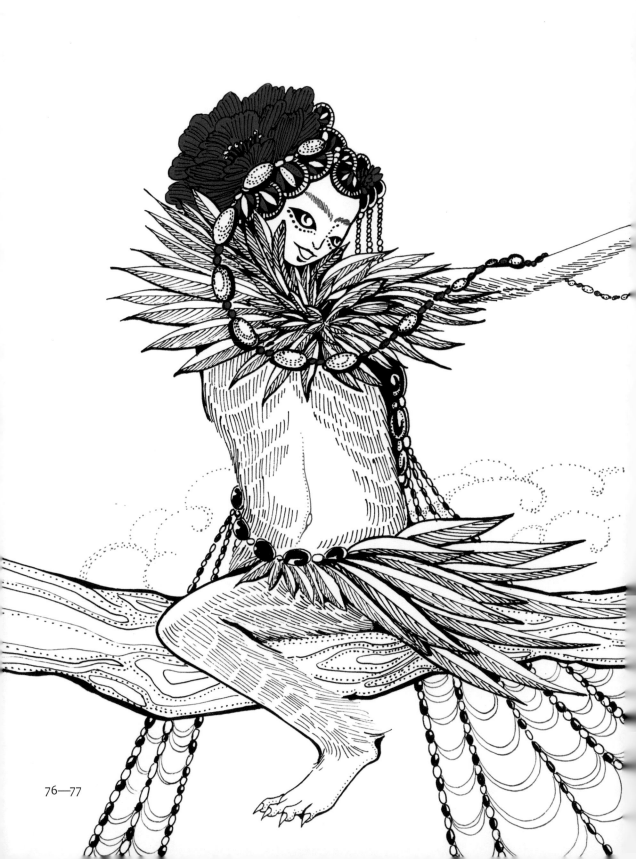

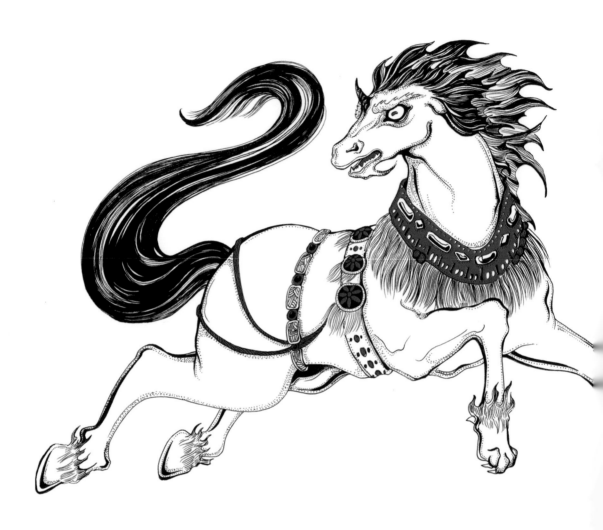

Bo 駁

有兽焉，其状如马而白身黑尾，一角，虎牙爪，音如鼓音，其名曰駁，是食虎豹，可以御兵。

Eight hundred fifty li due west of Gang shan lived an equine that spread good tidings from its home on Zhongqu shan. The majestic Bo had a pure white body, a pitch-black tail, and a single horn that pointed skyward from the bridge of its nose. Its teeth and front hooves resembled the fangs and claws of a tiger, though less pronounced. Possessing a drumbeat call, this domesticated creature protected human riders from the terrors of war, partly because it fed not on vegetarian fare, but on tigers and leopards. As it carried its rider through the dense woods of Zhongqu shan, even the most powerful predators kept their distance.

On one of Duke Huan of Qi's hunting trips, according to legend, he encountered a fierce tiger. Expecting the worst, he was amazed to see the menacing animal drop to the ground instead of pouncing. Why did it do that? he asked his minister, Guan Zhong, and was told that his mount was not a typical horse but a Bo, before which other animals bowed down. Sightings of this revered animal continued even as late as the Song dynasty.

Rupi 鳘鮍

滥水出于其西，西流注于汉水，多鳘鮍之鱼，
其状如覆铫，鸟首而鱼翼鱼尾，音如磬石之声，
是生珠玉。

Niaoshu tongxue shan stood four hundred eighty li west of
Zhongqu shan. An unusual fish proliferated in the Lan River,
which originated on the western slope of the mountain.
Endowed with an avian head, the Rupi produced pearls like
an oyster. Its shape was that of an overturned skillet, but one
with scales and a tail, behind the captivating head of a bird. It
had the discordant call of crashing rocks, a sound that evoked
mystery and charm. What truly made the Rupi otherworldly
was not merely its natural ability to produce pearls, but the
ease with which it scattered them in the water from its beak as
it swam. It was an inedible fish, owing probably to the nascent
jewels that dotted its flesh.

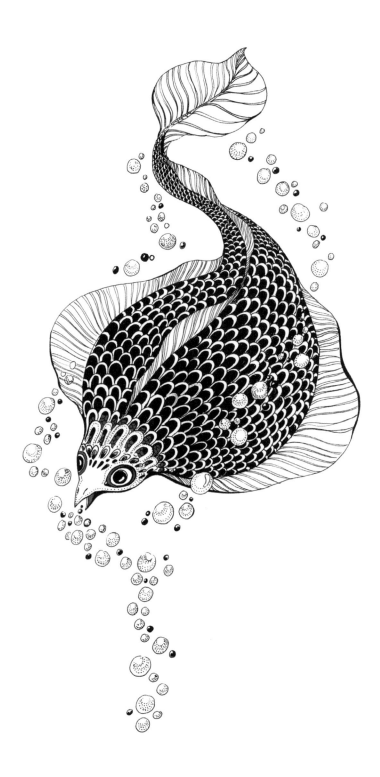

The Northern
Mountains
北山经

Heluo 何罗

谯水出焉，西流注于河。其中多何罗之鱼，
一首而十身，其音如吠犬，食之已痈。

In ancient times, a place known as Jiaoming shan, in the
vicinity of Mongolia's Zhozi shan, was the headwater of the Jiao
waterway, which emptied into the Yellow River. It was the home
of a freakish fish called the Heluo. Ten fish bodies, all of which
were attached to a single head with three sets of eyes, had
voices that sounded like barking dogs. The flesh of the Heluo
was an effective cure for edema. Anyone who could not bear
to eat the fish could raise them, for they served as a protection
against floods. The "kun" fish of Beiming in the Warring States
philosopher Zhuangzi's *Xiaoyao you (Free and Easy Wandering)*
could transform itself into a giant roc. The Heluo could
also change itself into a bird, one called a Xiujiu, which was
notorious for pilfering people's husked rice. But the Xiujiu was
deathly afraid of thunder and lightning, which invariably drove
it into hiding. Not so the Heluo.

Menghuai 孟槐

有兽焉，其状如貆而赤豪，其音如榴榴，
名曰孟槐，可以御凶。

While the Heluo swam in the Jiaoming River, which flowed
west from Jiaoming shan to the Yellow River, a large and
intimidating but somewhat shy member of the porcupine
family roamed the foothills of Jiaoming shan. The colorful
quills of the Menghuai grew out of a patch of soft hairs on its
cheeks and neck and were lethal. It made sounds like a creaky
winch at times and a purring cat at others. It had the power to
ward off evil forces in many forms and keep them at bay. After
the animal itself disappeared from sight and was thought to
have taken on other forms, imagined images of the original
creature were drawn and hung in homes, with surprisingly
good results at keeping evil from entering the premises.

Xixi 鰼 鰼

囂水出焉，而西流注于河。其中多鰼鰼之鱼，其状如鹊而
十翼，鳞皆在羽端，其音如鹊，可以御火，食之不癉。

The Xiao River originated on Zhuoguang shan, three hundred
fifty li north of Jiaoming shan, and was home to the Xixi, a
slim hybrid creature with the head and body of a fish, five
sets of winged fins, and a hooked avian beak. Its call was
remarkably similar to that of a magpie. Despite its ability to fly,
it represented the element of water, owing to the scaly surface
of its body and the watery medium in which it spent most of its
life, and since in the hierarchy of elements, water subdues fire,
the Xixi signified fire repression. If caught and eaten, its flesh
was thought to be a cure for jaundice.

Ershu 耳鼠

有兽焉，其状如鼠，而菟首麋身，
其音如獆犬，以其尾飞，名曰耳鼠，
食之不睬，又可以御百毒。

The mammoth Guo mountain range, which stretched north
to south some four hundred li, was three hundred eighty li
north of Zhuoguang shan. Two hundred li farther north stood
Danxun shan. One of the strange creatures that lived on this
mountain was the Ershu, an oversized rat with the head and
ears of a hare, the fawnlike body of a Mi deer, and the bark
of a hound. The extraordinary tail served as a wing, allowing
the Ershu to soar through the air, its flight stabilized by a
pair of long, pliant ears. The animal's meat had a variety of
applications, including the reduction of abdominal swelling,
as an antidote for many types of venom, and as a tonic that
eliminated nightmares. Modern medicine would classify its
flesh as a rare multipurpose therapeutic capable of curing
disease, preventing epidemics, and boosting mental health.

Youyan 幽鴳

有兽焉，其状如禺而文身，善笑，见人则卧，
名曰幽鴳，其鸣自呼。

Bianchun shan, a mountain three hundred ninety li north of
Danxun shan, was lushly covered with native vegetation and
fruit, including wild onions and mountain peaches. It was also
home to an entertaining, almost comical animal called the
Youyan. Adept at bounding from branch to branch high in the
forest canopy, it had the skills and appearance of a monkey,
though its fur was striped top and bottom and end to end. It
called its own name from morning to night, and seemed always
to be smiling or laughing. It loved to play tricks on humans,
feigning death or sleep, but its audience was never fooled into
letting it draw near.

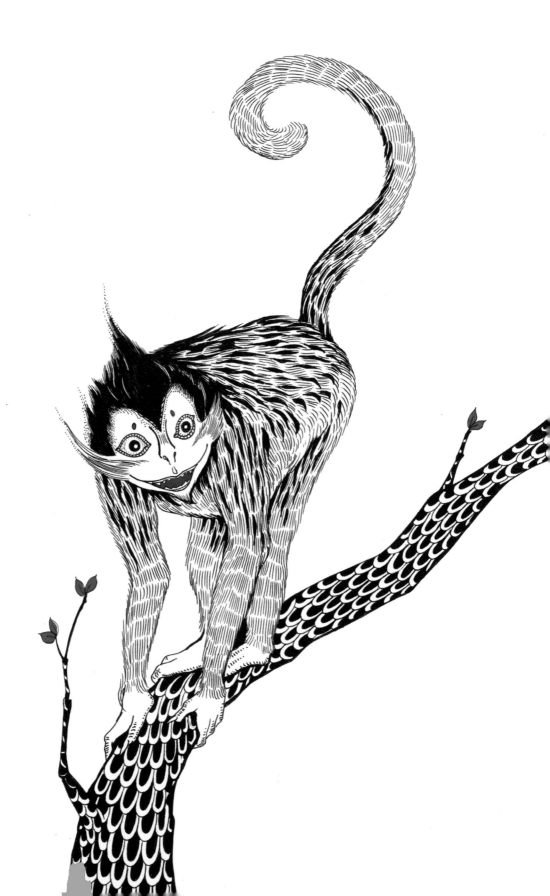

Zhujian 诸犍

有兽焉，其状如豹而长尾，人首而牛耳，一目，
名曰诸犍，善吒，行则衔其尾，居则蟠其尾。

The most unusual mythical species inhabiting
Danzhang shan, a curious mountain three hundred
eighty li from Bianchun shan, was a truly bizarre
ruminant called the Zhujian. It had a face whose
features seemed misplaced or underdeveloped, with a
single eye above embedded nostrils and a small mouth
between bovine ears. Its body was that of a very large
leopard, replete with spots, and an extraordinarily long
tail it kept off the ground when it walked by holding
it in its mouth. The reputedly prehensile tail lay coiled
beside the creature's body when it rested. Sightings
were rare, and some have speculated that it came out
mainly at night. Nothing is known of its temperament
or activities.

Changshe 长蛇

有蛇名曰长蛇，其毛如彘豪，其音如鼓柝。

The barren Daxian shan, a square mountain rich in jade deposits, was where a reptile aptly named a Changshe, a "Long Snake," made its home. Growing to the extraordinary length of eight hundred feet, it was at its most imposing when it rose up like a cobra and displayed the bristly filaments that grew out of its head and down the first few joints of its segmented body. Lacking the forked tongue of earthly snakes, it did not announce its presence with a hiss but produced a muffled thud like the late-night sound of a struck wooden clapper. No evidence exists to substantiate rumors of an even longer relative in a place called Yuzhang, one reaching ten thousand feet. Potential predators stayed clear of its territory, marked by a sidewinding trail in the sand and dirt.

Yayu 窫窳

有兽焉，其状如牛，而赤身、
人面、马足，名曰窫窳，其音如婴
儿，是食人。

A hideous appearance can instill
fear in humans, something that is
absolutely warranted in the case of
the man-eating Yayu, which roamed
the hollows of Shaoxian shan, one
mountain over from the larger
Dunhong shan. A massive bovine
with a frightful face that is almost
impossible to describe, thick horns,
horse hooves, and a ruddy hide, it
lured its victims with the deceptive
call of a whimpering infant. Thought
originally to have been a deity with a
human face and a reptilian body, it was
murdered by Erfu, a hostile deity, and
reborn as the man-eating Yayu. It then
came down to earth to terrorize an
entire mountain.

Yi 鮨

诸怀之水出焉，而西流注于嚣水，其中多**鮨**鱼，鱼身而犬首，其音如婴儿，食之已狂。

Long ago, in the remote past, a peak called Beiyue shan existed in what is now the Dorbod Banner region of Inner Mongolia. It was where the Zhuhuai River began its flow westward to the Qi River, waters that were hospitable to a strange fish called the Yi, with a fish body and the head of a dog. The Yi was eagerly sought by fishermen, who followed its whimpering cry. Its flesh was used to treat infantile convulsions and mental illness.

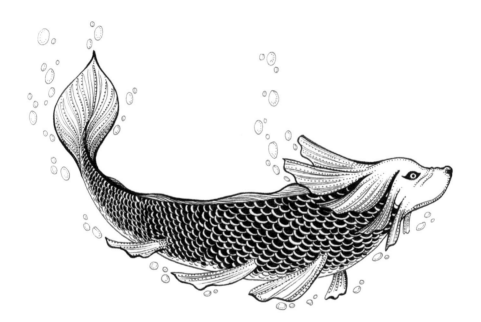

Feiyi 肥遗

有蛇一首两身，名曰肥遗，见则其国大旱。

A snake with one head and two bodies inhabited Hunxi shan, some hundred eighty li down a mountain path from Beiyue shan to the south. While its name sounds somewhat similar to Feiwei, the strange animal that lived on Taihua shan, recorded in the Western Mountains section, the Feiyi snake could not be more different. It glided along the ground by interweaving its two bodies in a braiding motion that left a distinctive series of figure eights in its wake. It did, however, share something with the Taihua shan Feiwei, in that it created droughts wherever it appeared. The connection could well not be coincidental, but no record that the two creatures are related exists.

Paoxiao 狍鸮

有兽焉，其状如羊身人面，其目在腋下，虎齿人爪，
其音如婴儿，名曰狍鸮，是食人。

On ancient Gouwu shan, in what is now the southern corner
of Shanxi Province's Shuozhou city, lived an animal called a
Paoxiao. Few mythical animals possessed as many mismatched
body parts as this man-eating hybrid. A freaky quadruped with
a strangely marked goat's body, it had a human head but with
curved, ramlike horns, the fangs of a tiger, and eyes that lay just
beneath the forelegs, which ended in humanlike hands with
long, tapered nails. It made a sound similar to an infant's cry. It
was a voracious eater that actually chewed on its own body as it
consumed its victims. While there is no documented evidence
of regeneration of consumed parts of the animal's body, the
missing flesh must have grown back in one shape or another,
perhaps adding to the misshapen whole. Taotie, the Paoxiao's
other, better-known name, is associated in modern Chinese
with gluttony.

Duyu 独 狢

有兽焉，其状如虎，而白身犬首，马尾彘鬣，名曰独狢。

Beiyu shan, a monolithic mass of earth without a single rock, stood three hundred li north of Gouwu shan. Yet it boasted a substantial yield of fine jade stones. It was home to the Duyu, an animal that resembled a foo dog or a Chinese guardian lion, with a tiger's body, the head of a canine, and a bristly horse's tail. Its three parts endowed it with a majestic, almost kingly bearing. Whether it roared, barked, or whinnied has never been recorded.

Ao 囂

有鸟焉，其状如夸父，四翼、一目、犬尾，
名曰囂，其音如鹊，食之已腹痛，可以止衕。

Liangqu shan, which stood three hundred fifty li north of
Bexiao shan, was dotted with gold and jade quarries, over
which a bird called an Ao soared. Resembling the legendary
Kuafu, who chased the blazing sun to ease the misery of the
people below, it possessed two sets of wings and the tail of
a dog. A single eye dotted the center of its head. Despite its
unusual physical characteristics, it had a melodic, pleasant call.
Consuming the flesh of an Ao bird lessened abdominal pains
and diarrhea in humans.

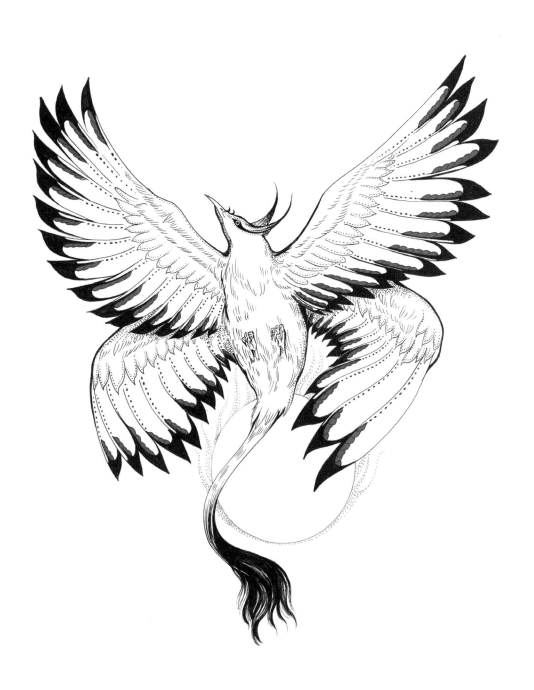

Renyu 人 鱼

决决之水出焉，而东流注于河。其中多人鱼，
其状如鲭鱼，四足，其音如婴儿，食之无痴疾。

Far back in antiquity, in the area northeast of the famous
Taihang shan, stood Longhou shan, which, like so many
other mythical mountains, lacked flora but produced many
valuable ores. The source of the Juejue River, which flowed
east to the Yellow River, was high up on the mountain's barren
peak, its shallows home to the bizarre Renyu, a "human fish."
Resembling a salamander, it had four legs, large eyes, and made
croaking noises like a colicky infant. It was not an attractive
creature but was coveted for its medicinal qualities, mainly the
treatment of incipient madness and dementia.

Tianma 天 马

有兽焉，其状如白犬而黑头，见人则飞，
其名曰天马，其鸣自讪。

Two hundred li northeast of Longhou shan, on Macheng shan,
lived a large white canine with a jet-black head and a long,
bushy tail. It was the Tianma—Sky Horse—a perennial bearer
of happy tidings, typified by the welcoming call it made—
tianma tianma, as if it were calling itself. For some reason,
either timidity or modesty, it fled at the first sight of a human.
Its advent augured great harvests for that year.

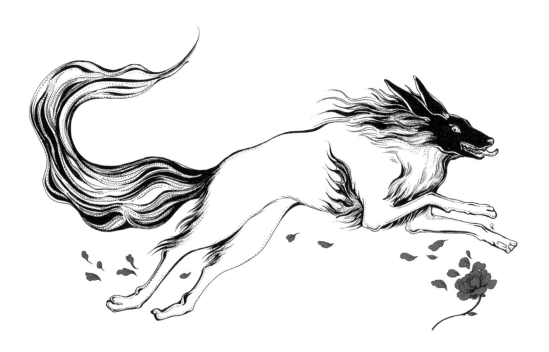

Jingwei 精卫

有鸟焉，其状如乌，文首、白喙、赤足，
名曰精卫，其鸣自詨。是炎帝之少女名曰女娃，
女娃游于东海，溺而不返，故为精卫。常衔西
山之木石，以堙于东海。

High up on Fajiu shan lived a bird that bore some resemblance to a raven but had a colorful head, a white beak, and red talons. It was the celebrated Jingwei, one of mythology's highest-profile creatures. Its name came from the call it made—*jingwei jingwei*. Before being reborn as a bird, Jingwei was Nüwa, daughter of the legendary ruler Yan, known as the Flame Emperor, ancestral to the Chinese people, and considered by many to be the same individual as Shen nong, the god of agriculture, who was credited with many agricultural inventions. When Nüwa was swimming in the Eastern Sea, she was unable to reach the shore and drowned. She then transmigrated into the Jingwei and was known to carry tree limbs and stones in an attempt to fill in the Eastern Sea, either as an act of ultimately futile vengeance against the sea or to prevent others from meeting the same end as she.

Dongdong 㹠㹠

有兽焉，其状如羊，一角一目，目在耳后，
其名曰㹠㹠，其鸣自讥。

The crags of Taixi shan, a mountain that once dominated the landscape of the northeast corner of Shanxi Province, were home to the sure-footed Dongdong, a shaggy-haired, goatlike creature with but one eye and one horn, the former behind one ear, the latter curving out from the opposite side of its forehead. Its name came from its persistent call of *dong—dong—dong*. Its appearance, according to legend, always led to bumper harvests in the lowlands around the mountain, cementing its reputation among the people as an animal worthy of reverence. Some believed, however, that it was an unlucky beast, whose appearance was a sure sign that something terrible would happen at the imperial court.

Yuan 獂

有兽焉，其状如牛而三足，
其名曰獂，其鸣自詨。

The shaggy-haired, horned Yuan, a slimmed-down version of the Central Asian yak, lived in the remote past on Gan shan, some four hundred li north of Yiqi shan. With two legs in front and only one in the rear, it had an awkward gait that accompanied its plaintive cry of *yuan—yuan—yuan*, from which it was given its name. Like the calls of many animals, it seemed intended to proclaim its existence.

Mashen renmian shen 马身人面神

凡北次三经之首，自太行之山以至于无逢之山，
凡四十六山，万二千三百五十里。其神状皆马身而人面者
廿神。其祠之，皆用一藻茝，瘗之。

Three mountain ranges appeared in the Northern Mountains.
The third range stretched from Taihang shan to Wufeng shan,
with a total of forty-six peaks across a distance of 12,350 li.
The mythical creatures that lived on twenty of those peaks
were horses with the heads and torsos of humans. When
paying homage to these often warriorlike equines, worshippers
buried offerings of fragrant grasses such as aquatic grasses and
angelica.

The Eastern Mountains
东山经

Tongtong 狪 狪

有兽焉，其状如豚而有珠，
名曰狪狪，其鸣自讥。

The Tongtong lived on Tai shan far back in the remote past. It derived its name from its call of *tong—tong*. Larger than the common pig and bearing a striking resemblance to a wild boar, but with a beaded mane along its backbone past its shoulders, it had a digestive system that produced pearls. While this is an unusual distinguishing characteristic, to say the least, the Tongtong had its aquatic counterparts in the Rupi fish of the Lan River in Niaoshu tongxue shan, and the Zhubie that swam in the Lishui. It has been referred to as the Pearl Swine.

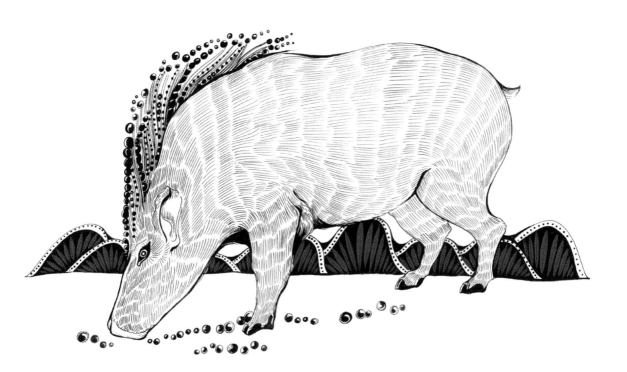

Zhubie 珠 鳖

澧水出焉，东流注于余泽，其中多珠鳖鱼，
其状如肺而有目，六足有珠，其味酸甘，
食之无疠。

Four eyes and six legs on a floating lung is an apt description
of the aquatic Zhubie, which swam in the Lishui River that
emanated from the front slopes of Ge shan. Like the Tongtong
of Tai shan and the Rupi of the Lan River, it produced pearls,
which it spewed as it moved through the water. It was highly
sought after by fishermen for its excreted jewels, but not for its
flesh, which had a sour taste, though with a hint of sweetness.
It was considered a gourmet dish by Lü Buwei, chancellor of
Qin Shihuang, the First Emperor. The patterned skin on the
Zhubie's back lent it the appearance of a turtle, which was why
it was referred to as a pearl turtle. The flesh had the additional
effect of keeping the eater free of seasonal diseases and immune
to pestilences.

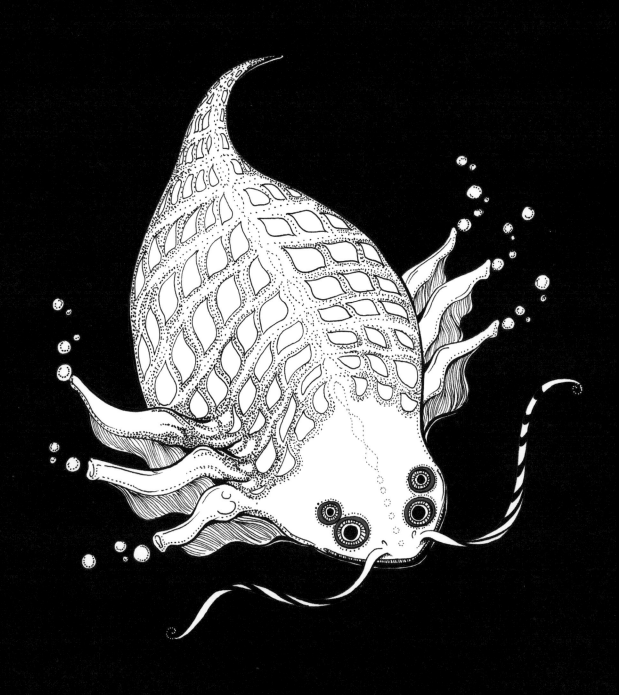

Qiuyu 犰 狳

有兽焉，其状如菟而鸟喙，鸱目蛇尾，见人则眠，
名曰犰狳，其鸣自讠，见则螽蝗为败。

Three hundred eighty li south of Ge shan stands a mountain on which catalpa and nanmu grew in profusion. The foot of Yu'e shan was rife with brambles and wolfberry shrubs, sometimes called goji berry shrubs. Amid all the flora existed an animal whose appearance defies description. The Qiuyu, a vicious little creature that looked a bit like a rabbit, with long plumes and a gaudily patterned body, had a corvine beak, an owl's eyes, and a rat's tail. It feigned death, rolling into a ball like a pangolin at the sight of a human with what sounded like a muffled death cry of *qiu yu—qiu yu—qiu yu*, which lent it its name. Whenever it made an appearance out of the shrubbery, locusts descended upon the land, devouring everything in sight and leaving behind a wasteland.

Zhunuo 朱獳

有兽焉，其状如狐而鱼翼，其名曰朱獳，
其鸣自讯，见则其国有恐。

A journey of six hundred li south from Yu-e shan took the
traveler to Liaogeng shan, home to another savage beast, called
the Zhunuo. The back of this cunning foxlike creature, which
wore a perpetual smirk, was covered with what appeared to be
scaly skin, behind sets of winglike fins that decreased in size
but whose function remains a mystery. The sound it made was
like a warning to people: "I'm coming, you'd better watch out!"
it seemed to be saying. A single appearance by the Zhunuo
inevitably created chaos throughout the country, leading to
social, political, and financial instability everywhere.

Gege 鮯 鮯

有鱼焉，其状如鲤，而六足鸟尾，
名曰鮯鮯之鱼，其鸣自讠。

In what is today's Shandong Province, a mountain called
Jizhong shan was the site of a great marshland, Shenze, some
forty li in size. A fish called the Gege, which closely resembled
a carp, was found in its waters. Capable of diving to great
depths, this hybrid swimmer had a lengthy red-tipped forked
tail and three pairs of legs. Its *ge ge* call portended no disaster,
big or small, but what made the Gege truly unique was the fact
that it was born live from its parent, not from an egg, like all
other fish, then and now. That curious fact, together with the
presence of feet, indicates that the Gege may have spent time
both in the water and on land. No mention of it as food has
ever surfaced.

Geju 猲 狙

有兽焉，其状如狼，赤首鼠目，其音如豚，
名曰猲狙，是食人。

Beihao shan was located near the Northern Sea, into which the
waters of the Shishui flowed in a northeasterly direction from
high in the mountain. It was rich in both flora and fauna, with
unusual trees, sacred birds, and strange animals. The Geju was
one of those. In nearly every respect, it looked like a wolf. It
differed from the more common wild canine with its red facial
fur, a tail like a horse, and ratlike eyes. It grunted like a pig. It
also happened to be a man-eater.

Bo 薄

石膏水出焉，而西注于鬲水，
其中多薄鱼，其状如鳣鱼而一目，
其音如欧，见则天下大旱。

A one-eyed eel-like fish called the Bo dominated marine life
in the Shigao River, which originated on Nüzheng shan and
flowed west into the Ge River. It emitted a horrible noise as it
menaced its way through the clear waters, like the sound of a
person retching. People said that it caused drought if spotted
in areas it submarined through, while others said it spawned
floods. Some even insisted that the Bo somehow fostered
rebellions on land. Whatever the truth, it was a twisting catalyst
for disaster.

Heyu 合窳

有兽焉，其状如彘而人面，黄身而赤尾，
其名曰合窳，其音如婴儿。是兽也，
食人亦食虫蛇。见则天下大水。

The Shan shan rose roughly two hundred li from the western
edge of present-day Shandong Province. Its ridges and gullies
were dominated by a fierce and disturbingly unattractive
man-eating beast called the Heyu. The body of a wild boar was
capped by the scowling face of a man with menacing, staring
eyes, a ruff of bristly hair, the ears of a goat, and a prominent
snout. The man-eating creature had leathery yellow skin but an
almost perversely beautiful red and white tail. It whined like
an infant. When larger prey was unavailable, the Heyu feasted
on snakes and burrowing creatures. Disastrous floods occurred
wherever it appeared.

The Central Mountains
中 山 经

Huashe 化蛇

其中多化蛇，其状如人面而豺身，
鸟翼而蛇行，其音如叱呼，见则其邑大水。

The sandy, barren surface of Yang shan suited the Huashe, a bizarre hybrid that slithered across the rocky soil but could lift into the air, thanks to a pair of massive wings attached to the body of what appeared to be a jackal. A bland humanoid face did not prepare the viewer for the long serpentine tail that moved in a whiplike motion to serve as a propulsive force and a weapon. The Huashe's bawling call was like a high-pitched harangue. Like other ancient beasts, it created floodwaters wherever it went.

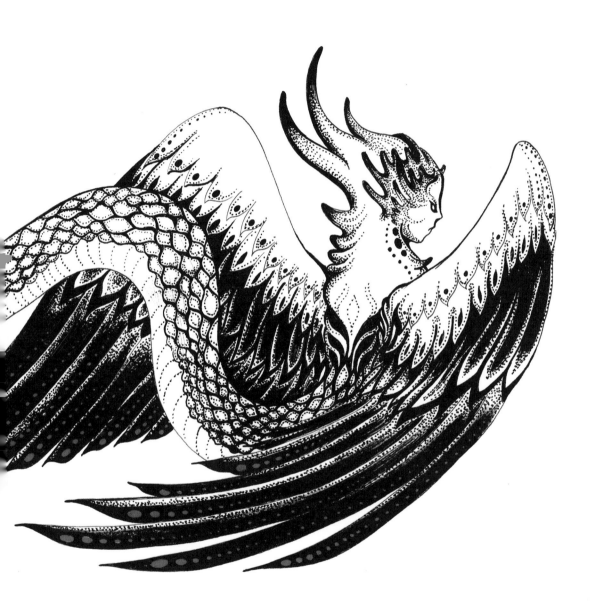

Fuzhu 夫诸

有兽焉，其状如白鹿而四角，
名曰夫诸，见则其邑大水。

Ao'an shan, a mountain north of what is now Hunan's Gongyi
City, was where, in ancient times, the god Xunchi dwelled.
Principal among the mountain's fauna was a handsome animal
called the Fuzhu, a deer whose pelt was an unblemished white.
Unlike common stags, the Fuzhu had a rack of four horns. Its
appearance was a harbinger of disastrous floods in the foothills,
and many people attributed the province's history of frequent
flooding to the advent of the Fuzhu.

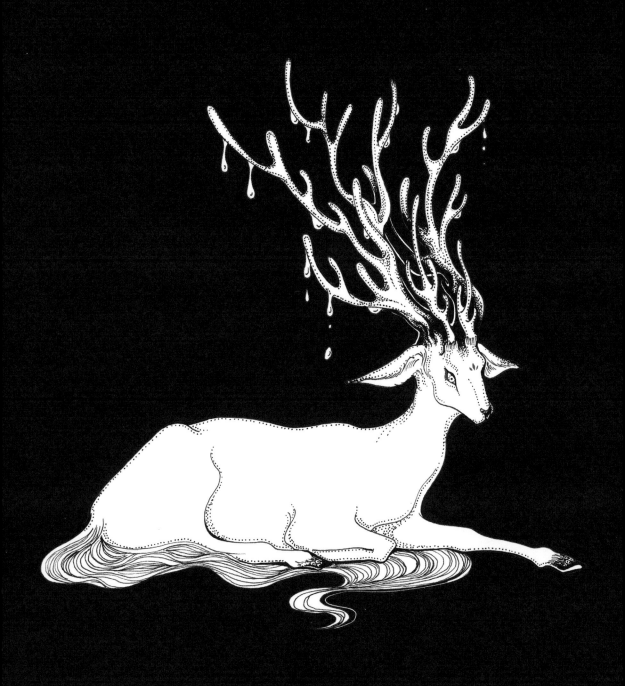

Jishen Taifeng 吉神泰逢

吉神泰逢司之，其状如人而虎尾，
是好居于萯山之阳，出入有光。
泰逢神动天地气也。

The peaks of He shan, in present-day Henan Province, wound
tortuously around the mountaintop, with five separate folds
as the gathering spot for nine tributaries of the Yellow River.
The waters flowed from all directions to meet at the mountain
and cascade as one into the Yellow River. Taifeng, believed
to be a Jishen, an auspicious god with an exaggerated human
face and a long tiger's tail, was in charge of the place. He
favored the southern slope, with its exposure to the sun.
Flashes of light accompanied Taifeng as he moved around the
mountain, forming clouds and sending down rain. According
to legend, he once raised a fierce wind that blotted out all light,
causing one of the Xia kings, Kong Jia, who was on a hunting
expedition, to lose his way.

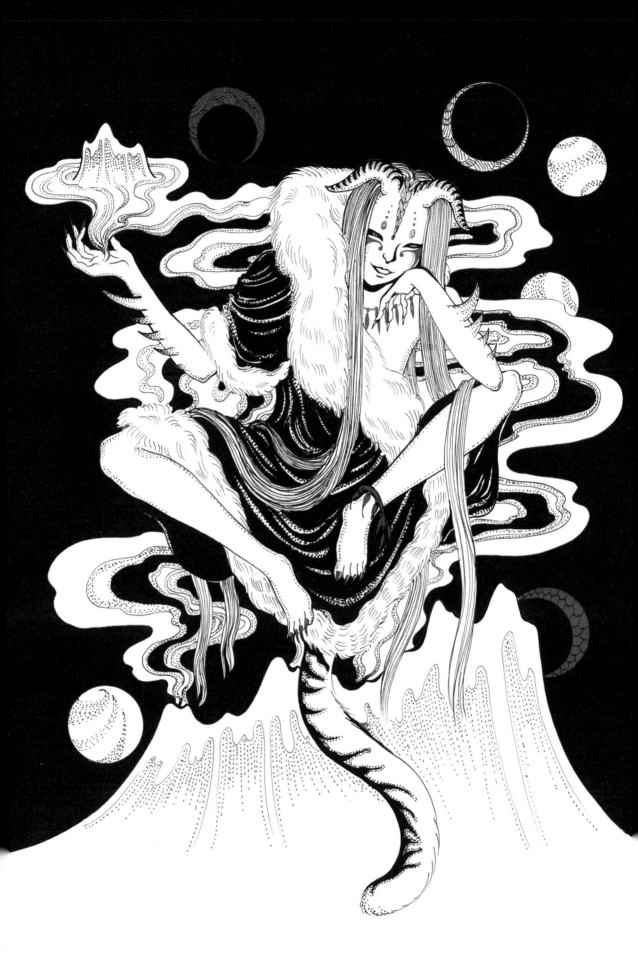

Xie 獬

有兽焉，名曰獬，其状如獳犬而有鳞，
其毛如彘鬣。

In ancient times, Li shan, located in present-day Henan
Province, produced jade on its southern slopes and madder,
a source of red dye, on its northern slopes. There dwelled an
animal that resembled a snarling dog, but with scales where
the fur ought to be. Bristly hair grew in the spaces between the
scales.

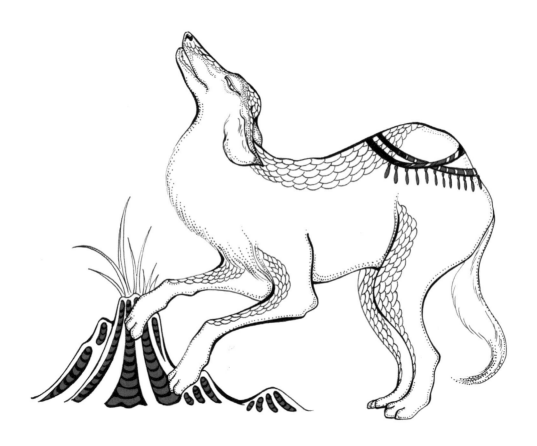

Jiaochong 骄 虫

有神焉，其状如人而二首，名曰骄虫，
是为螫虫，实惟蜂蜜之庐，其祠之，
用一雄鸡，禳而勿杀。

Jiaochong, a strange two-headed, humanlike god that was
in control of insects with stingers, lived on Pingfeng shan, a
barren, rocky mountain that was a gathering place for swarms
of bees. Local inhabitants brought out a large rooster to appease
Jiaochong, a menacing creature with four dissimilar eyes,
and beseech it to refrain from releasing the stinging insects
it controlled. Once the rite was concluded, the rooster was
released rather than slaughtered, which in itself was a departure
from tradition.

Lingyao 鸰 鹞

其中有鸟焉，状如山鸡而长尾，
赤如丹火而青喙，名曰鸰鹞，
其鸣自呼，服之不眯。

A mere twenty li west of Pingfeng shan stood Gui shan, a jade-
rich mountain on which an unusual bird, the Lingyao, lived.
Resembling a pheasant of modern times, it had a long, sinuous,
almost prehensile tail, a body as red as a fall maple leaf, and a
green beak, the contrast making it one of the loveliest birds of
its day. Its unique call—*lingyao, lingyao*—is how it got its name.
Its edible meat was an effective inhibitor of nightmares, keeping
evil and demonic spirits—which, in the eyes of the ancients,
were largely the cause of bad dreams—at bay.

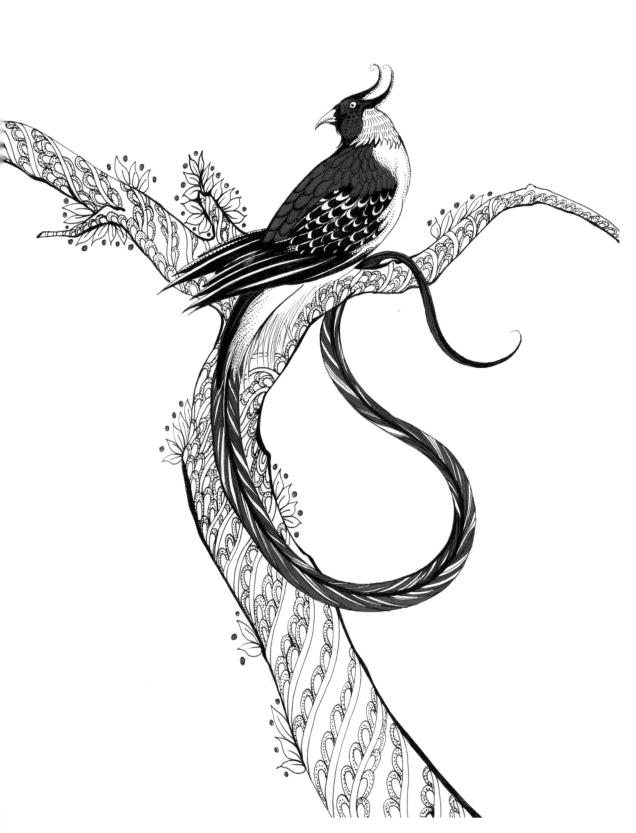

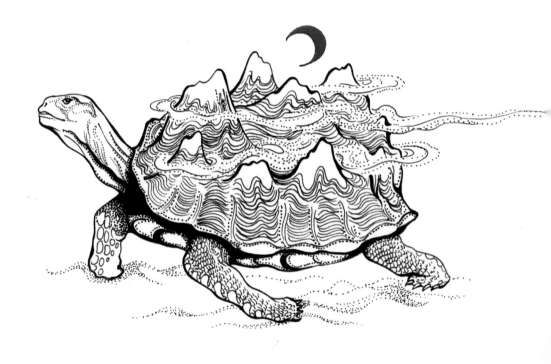

Sanzugui 三足龟

其阳狂水出焉，西南流注于伊水，其中多三足龟，
食者无大疾，可以已肿。

The Kuang River began its southwestern journey from Daku
shan and flowed into the Yi River. An odd turtle, the Sanzugui,
made the Kuang its home. In ancient times, turtles were
symbols of good luck, considered to be one of the four sacred
animals, along with the dragon, the unicorn, and the phoenix.
This slow-moving amphibian had only three legs and was
prized for its meat, which kept the eater free of major diseases
and cured painful swelling. Most people who ate the flesh of
three-legged turtles from other rivers died from it, while those
feasting from the Kuang River were spared life-threatening
diseases and avoided seasonal epidemics. It was truly an
exceptional creature even among its own kind.

Tuowei �milieu 围

神�milieu围处之，其状如人面。羊角虎爪，
恒游于雎、漳之渊，出入有光。

The Tuowei god was in permanent residence on jade-rich Jiao
shan. Though possessed of the physiognomy of a human, it had
elaborate horns, an alligator's body, and a pair of tiger's claws.
Tuowei was in the habit of visiting nearby rivers to frolic like
most amphibians in their deep waters, and wherever it went it
was encircled by what appeared to be a sacred glow. Whether
or not it made any sounds, and if so, what they might have
been, has not been recorded.

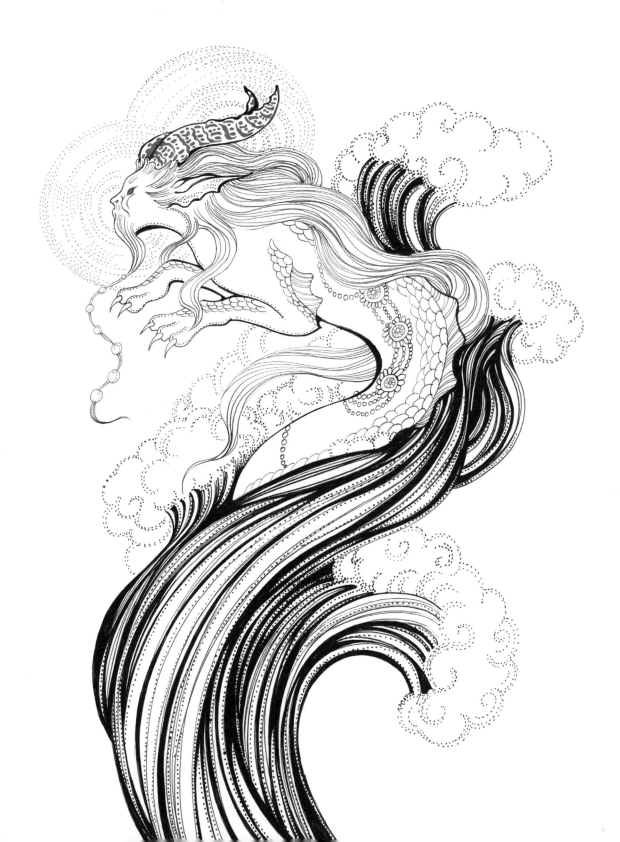

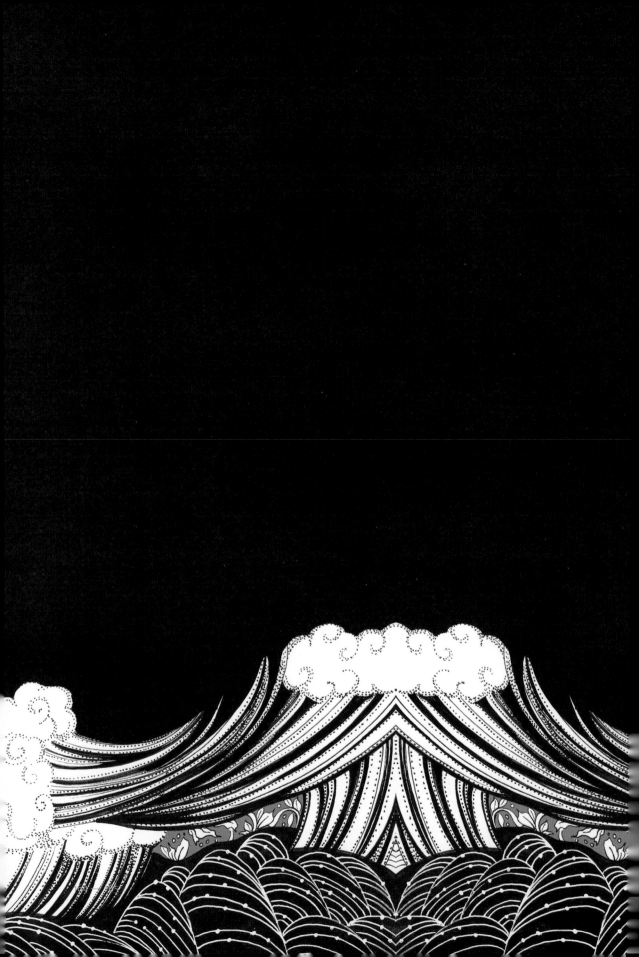

神计蒙处之，其状人身而龙首，恒游于漳渊，
出入必有飘风暴雨。

Guang shan, it appears, was the ancient name
of Geyang shan, some eighty li northwest of
Guangshan County in present-day Henan Province.
It was where the god Jimeng resided in the remote
past. With a horned dragon's head over a human
body, Jimeng was in the habit of roaming the waters
of Zhang Yuan, always accompanied by fierce
winds and torrential rains, an event characterized
by the popular saying, "Dragons bring winds
and clouds; welcome rains are the dragon's
companions."

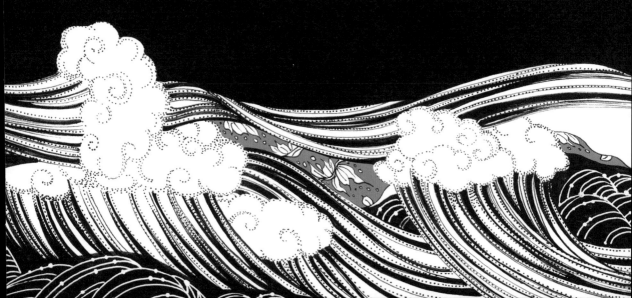

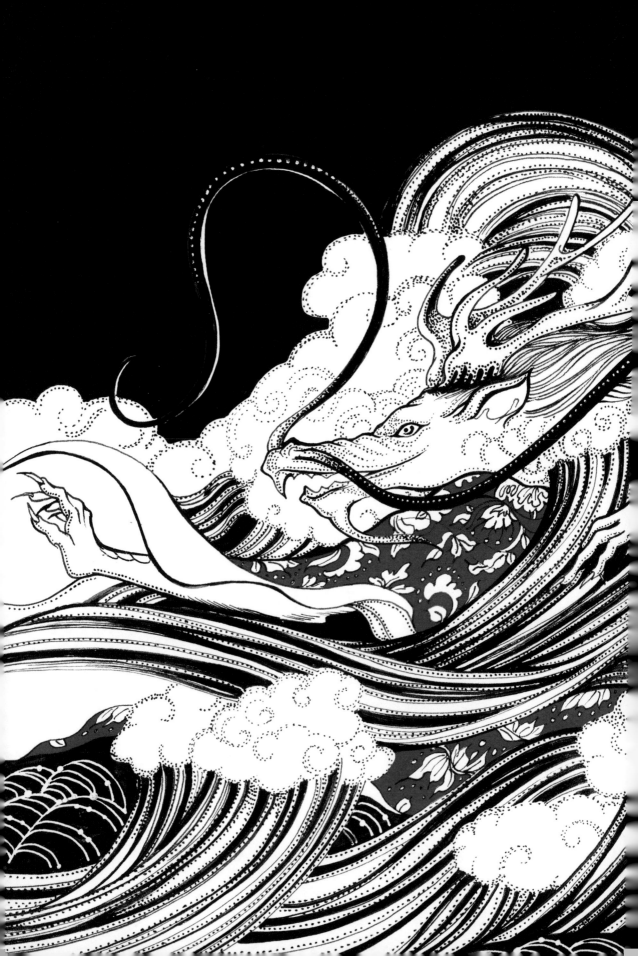

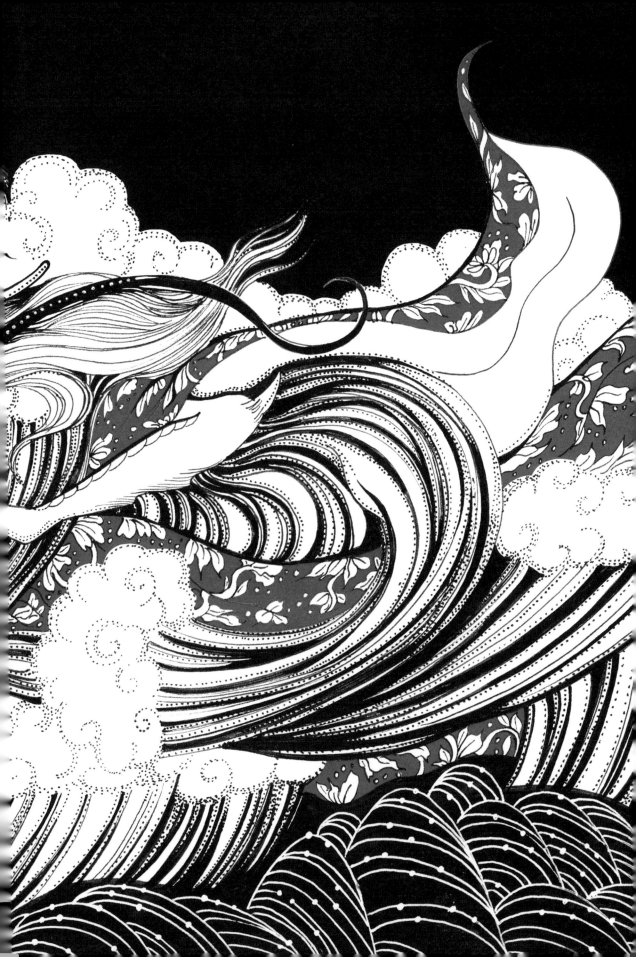

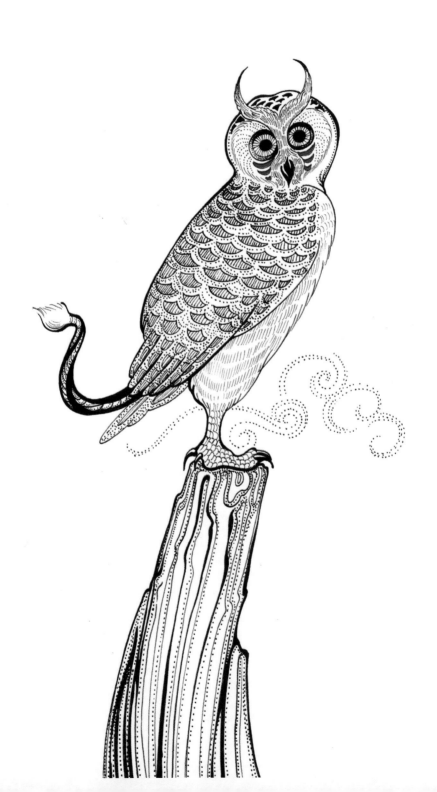

Qizhong 跂 踵

有鸟焉，其状如鸮，而一足彘尾，其名曰跂踵，
见则其国大疫。

The location of Fuzhou shan remains a mystery,
but it most likely stood somewhere in the southern
provinces. Sandalwood and gold were its most
prominent yields. A bird called the Qizhong dwelled
amid its forests. Bearing a striking resemblance to
the present-day owl, it had but one leg and a single
talon, and instead of tail feathers was followed by
an elongated pig's tail, which must have inhibited
its ability to fly. One thing is for certain: it was a
cause of fear and apprehension, since a nationwide
outbreak of crippling diseases inevitably followed its
appearance.

Yingshao 嬰勺

有鸟焉，其名曰嬰勺，其状如鹊，赤目、赤
喙、白身，其尾若勺，其鸣自呼。

The Yingshao, an otherwise common bird except for the spoon shape of its colorful tail, made its home on Zhili shan, in what is now the southern part of Henan Province. Its red eyes and fiery red beak were in stark contrast to its black and white body feathers. People at the time got the idea from the bird's tail to make a type of ladle for serving wine and liquor.

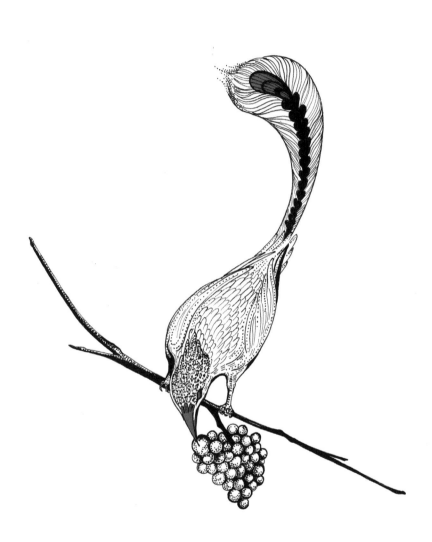

Juru 狙如

有兽焉，其状如鼣鼠，白耳白喙，
名曰狙如，见则其国有大兵。

Yidi shan, another mountain in present-day Henan, was home
to a tiny but ominous rodent called the Juru. It had floppy
rabbit ears and a white pointed snout. Its diminutive size
belied the devastation it left in its scurrying tracks across the
landscape, including outbreaks of chaos and even war.

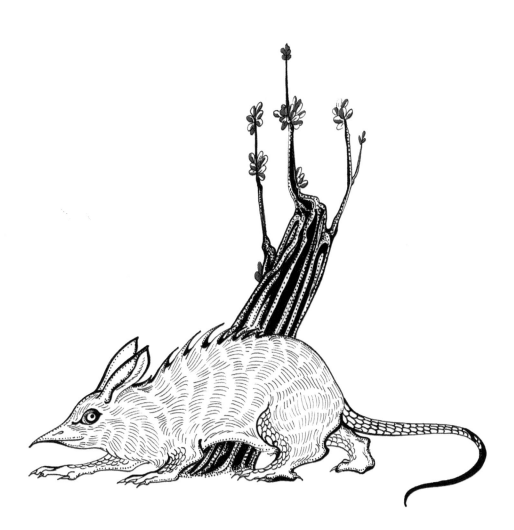

Yu'er 于 儿

神于儿居之，其状人身而手操两蛇，
常游于江渊，出入有光。

The god Yu'er made its home in Fufu shan, located
somewhere in present-day Hunan Province. Like
the Guanyin Bodhisattva, Yu'er had the magical
power to change its body into any desired form and
must be considered neither male nor female. The
god has been portrayed as both and was thought to
look like an ordinary woman. What distinguished
this deity were two fearsome snakes that
intertwined around her, though some have insisted
that she is holding them in her hands. Like many
other gods, Yu'er delighted in water amusements
and emitted a brilliant light whenever she came and
went. Yu'er exhibited virtually all human physical
features, all but the snakes, which never left her.
The reptiles likely connected their host to the
human and divine worlds.

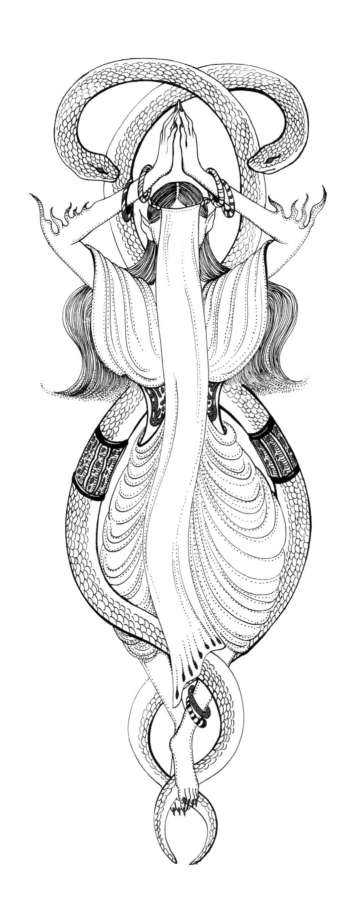

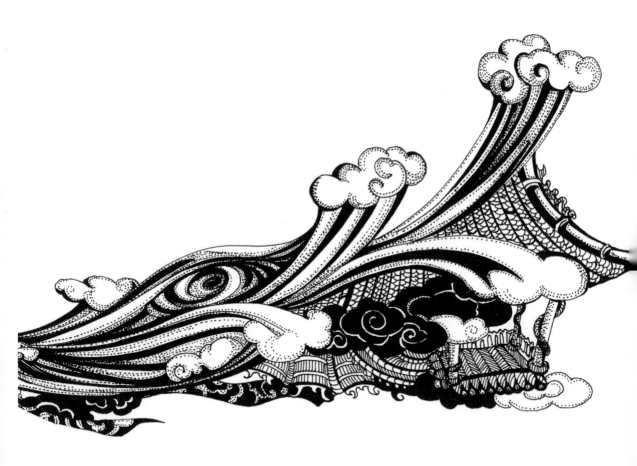

Di zhi ernü 帝之二女

帝之二女居之，是常游于江渊。澧沅之风，
交潇湘之渊，是在九江之间，出入必以飘风暴雨。

Dongting shan was the ancient name for present-day Jun shan, located on the north shore of Dongting Lake. It is where the two daughters of the supreme god Di dwelled, and where they roamed the land around the waters of the Changjiang. Breezes from the Li and Yuan Rivers came together at the Xiao and Xiang Rivers, a spot known as the merging of Nine Rivers. Fierce winds and rainstorms accompanied them on all their visits. The daughters of Di, Ehuang and Nüying, were both married to Yao's son, Shun. They saved him from several assassination attempts by family members, though he subsequently died on a trip to Cangwu in the south and was buried at Jiuwu shan. They followed their husband's footsteps to the Yuan and Xiang Rivers, where their tears of sorrow landed on bamboo, creating spots that never went away. They threw themselves into the Xiang River and, with their husband, became the Three Xiang River Gods. They were memorialized by the great poet of the Warring States period, Qu Yuan, in his celebrated *Nine Songs*.

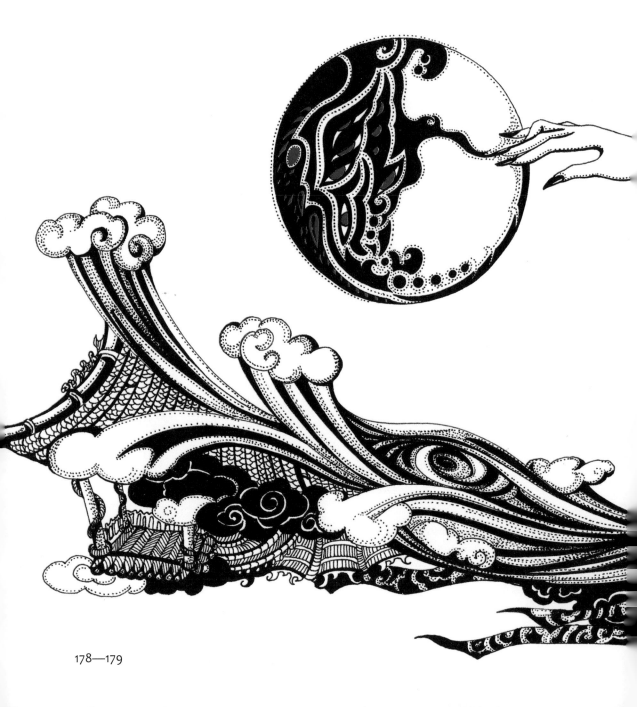

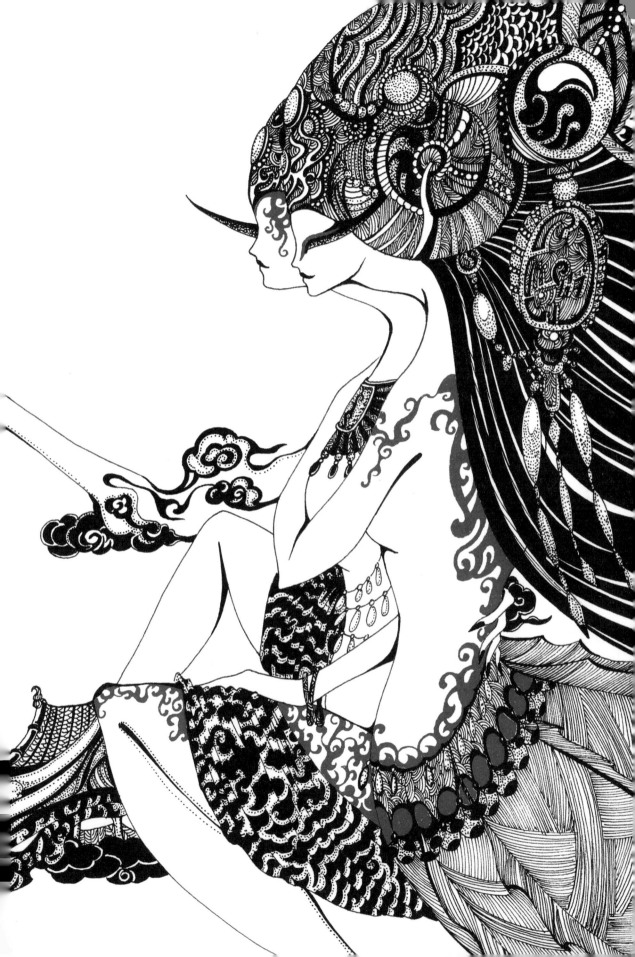

Seas Classic
海经

Southern Lands
Beyond the Seas
海外南经

Biyi 比翼鸟

比翼鸟在其东, 其为鸟青、赤, 两鸟比翼。
一曰在南山东。

"In the sky, oh, to be a Biyi, Shared-Wing Bird;
on earth, oh, to be conjoined branches." The Biyi
had a black-and-white body that resembled a wild
duck, here pictured as a crane. It had but one eye,
one wing, and a crestlike filament that curled out
from the head. Only when two of the birds, often
described as one green and one red, came together
could they fly. The two birds were paired only to
sustain their existence and not to mate, though
that has not kept humans from adopting the Biyi
as a symbol for conjugal love. Quite possibly, there
are many beautiful images that stem from human
misunderstandings such as this, but without
apparent harm.

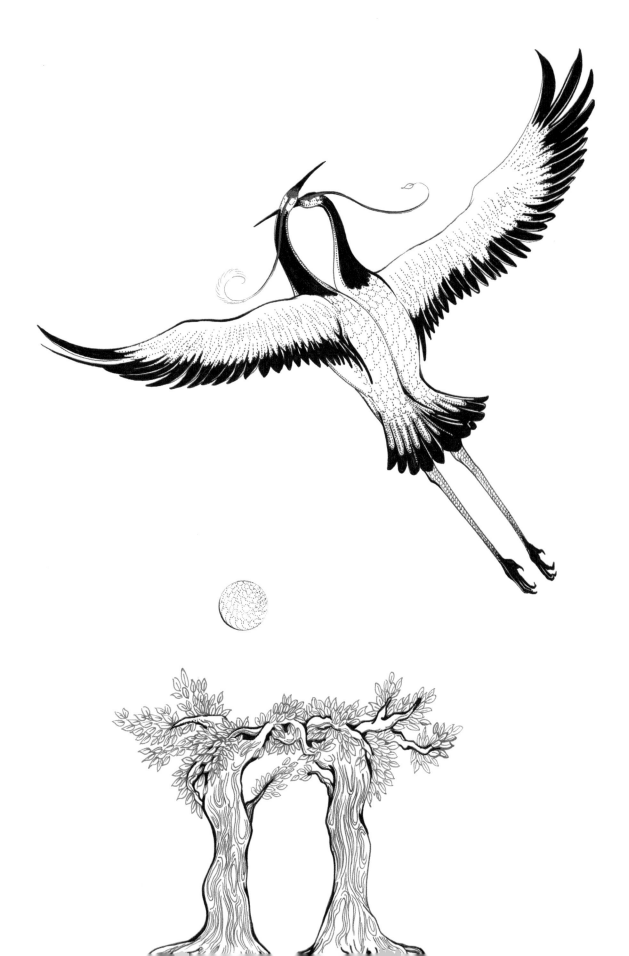

Yumin 羽人

羽民国在其东南，其为人长头，身生羽。一曰在比翼鸟东
南，其为人长颊。

The Land of Feathered People, situated 43,000 li from Jiuyi
shan, has been described in other classics, such as the
Huainanzi (The Huainan Masters) and the *Bowu zhi (Records
of Diverse Matters)*. The land was home to a race of strange
creatures called Yumin. While they had somewhat human
facial features—long heads and elongated faces with red
eyes and short hair, some white, some black—their mouths
functioned like birds' beaks. Their bodies were covered with
feathers, the largest of which formed a pair of wings. They not
only had avian characteristics, including the ability to stand on
one leg, but were born from eggs. Like all birds, Yumin could
fly, but only for short distances. They fed on the eggs of such
fabled birds as the phoenix.

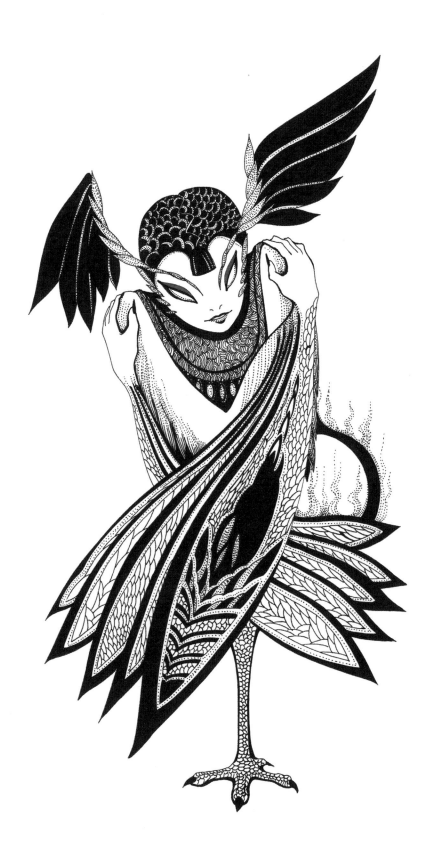

Erba shen 二八神

有神人二八，连臂，为帝司夜于此野。在羽民
东。其为人小颊赤肩。尽十六人。

On the eastern coast of the Land of Feathered
People lived the Two-Eight Gods, articulated
figures with sixteen conjoined arms. The arms
belonged to inhabitants with small faces and red
shoulders, forming a creature that guarded the
night for the supreme god, the Yellow Emperor.
They made an impenetrable barrier, able to move
freely. They were never seen during the day. The
night-traveling god of a later time may have
evolved from this creature.

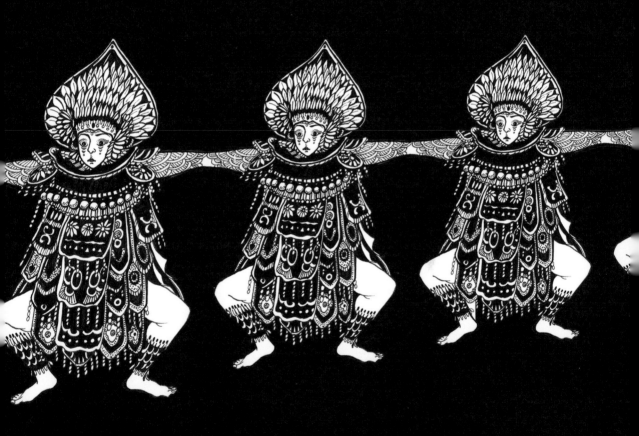

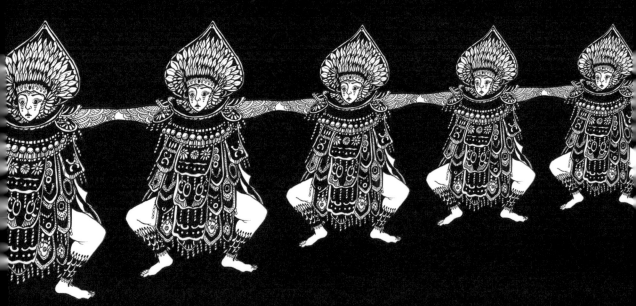

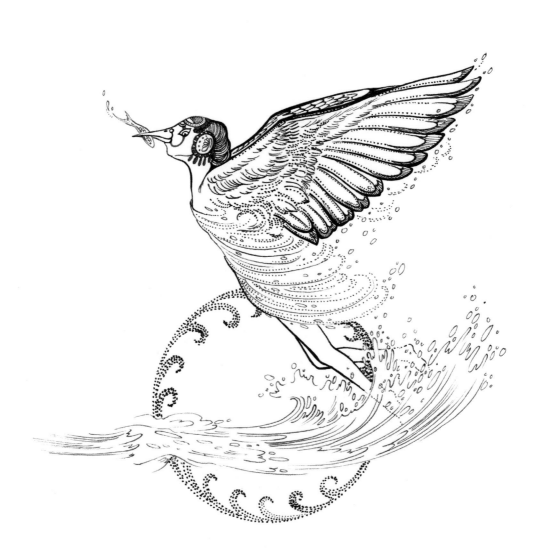

Huantou min 讙 国人

讙头国在其南，其为人人面有翼，鸟喙，方捕鱼。

The origins of Huantou land are difficult to pin down. Some say it dated back to the mythical "four malevolents" in the time of Yao and Shun. Yao's disloyal minister Huandou conspired to dethrone him and was exiled to the Southern Sea, where he died. Shun took pity on his son and enfeoffed him as the leader of the land of Huantou. A second myth has the exiled minister as Yao's son Dan Zhu. Outraged by the decision to anoint Shun as his successor, Dan Zhu joined forces with a Sanmiao tribal chieftain to launch a renegade offensive against his father. When the rebellion was put down, a defeated Dan Zhu threw himself into the Southern Sea. After his death, his unreconciled soul assumed the shape of a Zhu bird. Myths have arisen around the Zhu bird, who had the beak and wings of birds, though the face bore some resemblance to humans. The wings could not take them soaring in the air and served only as walking aids. Day in and day out, they supported themselves on the wings, using them as canes as they fished in the sea.

Yanhuoguo 厌火国

厌火国在其国南，其为人兽身黑色。生火出其
口中。一曰在讙朱东。

The Land of the Fire Eaters was thought by some to
be south of Huantou land, by others to the east. The
inhabitants stood erect and had faces that looked
somewhat human. They were, however, wild
animals, with thick coats of fur and prehensile feet,
much like monkeys. They survived by eating hot
coals and were said to be fire-breathers. They are
also described in *Records of Diverse Matters*. They
were as mobile and comfortable on land as in the
canopies of tall trees.

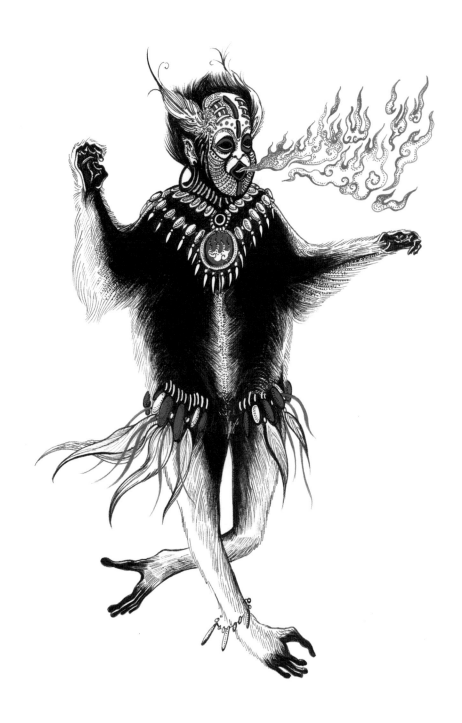

Sanzhu shu 三珠树

三珠树在厌火北，生赤水上，其为树如柏，叶
皆为珠。一曰其为树若彗。

The Sanzhu shu, known as the Three Pearl Tree,
grew on the bank of the Chi River on the north
edge of Yanhuoguo. While it had the appearance
of a cypress, all its leaves were pearls, and from
a distance, it looked like a comet. According to
legend, when the Yellow Emperor was on his way
back after climbing Kunlun shan to the north of
the Chi River, he lost his black pearl in a careless
moment. He sent four members of the court to find
it, which they eventually did. The Three Pearl Tree
could possibly have grown out of the lost pearl.

Guanxiongguo 贯 匈 国

贯匈国在其东，其为人匈有窍。

Guanxiongguo, the Land of Perforated Chests, lay beyond the nation's borders. The people had large holes in their chests, supposedly caused by a suicide attempt from a failed uprising against King Yu, who had killed one of their elders for being late to court. Yu understood how they felt and gave them Immortality Grass to fill their chest cavities. Over time, their heirs, all with holes in their chests, grew into a country, where those with high social status traveled not in wagons or sedan chairs, but went about, naked from the waist up, carried by bamboo or wooden poles through their chests.

Jiaojingguo 交胫国

交胫国在其东，其为人交胫。一曰在穿匈东。

Jiaojingguo, the Land of Crossed Legs, lay east of the Land of
Perforated Chests. The bones of its hairy inhabitants had no
joints, so their legs intertwined. When they lay down, lacking
the help of others, their strength was useless in getting back
up. Some claim that the actual intertwining occurred when
the necks of two people walking together wove together. Their
survival required the combined efforts of entire communities.

Hou Yi zhan Zaochi 后羿斩凿齿

羿与凿齿战于寿华之野，羿射杀之。在昆仑虚东。羿持弓矢，凿齿持盾。一曰持戈。

King Yi, the archer, was a heroic god of the remote past who was given a magical bow and arrows by the Yellow Emperor and sent to earth to save the people from their miseries. Not only did they suffer from being scorched by ten suns, nine of which he shot down, but they were terrorized by windstorms; the nine-headed monster that cried like a baby in the south; a big-mouthed creature, Zaochi, in the north; and an evil python. King Yi's wife, Chang'e, stole an elixir of immortality from him and escaped to become the moon goddess. Some say that Zaochi was a human, armed with spear and shield; others claim he was a beast with teeth like awls. He battled King Yi on the plains east of Kunlun shan, and was killed by an arrow.

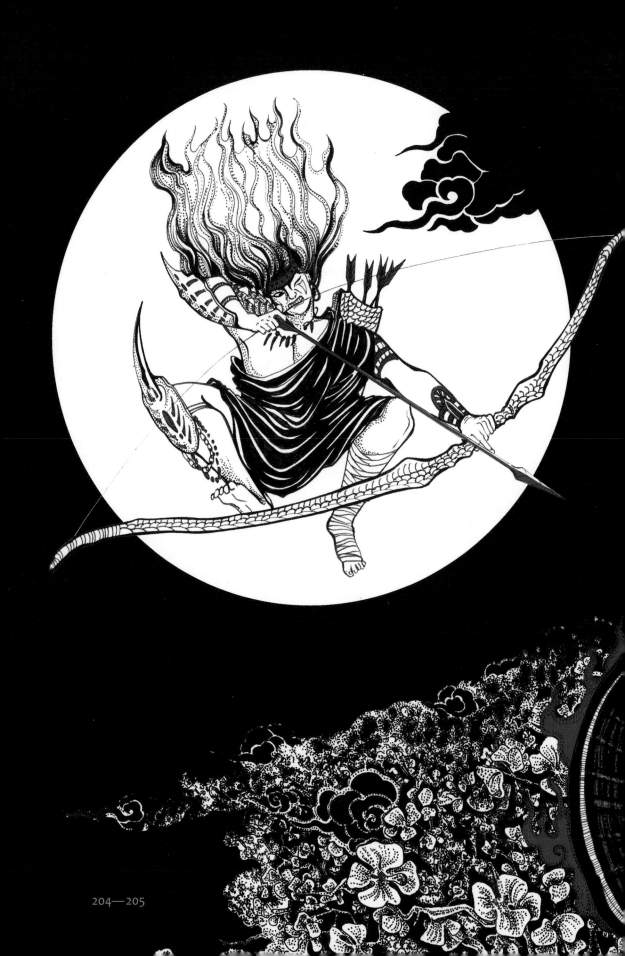

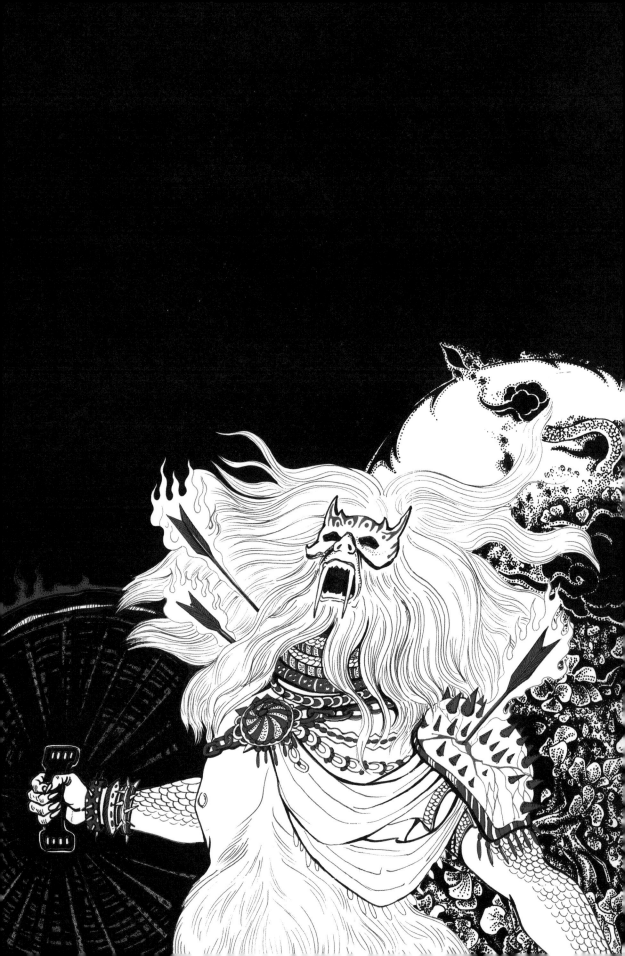

Zhurong 祝融

南方祝融，兽身人面，乘两龙。

Fire god Zhurong of the south had a human face, fiery red hair, and the body of a wild animal. He rode two dragons and was said to be in charge of the summer months, which makes perfect sense, considering the blistering heat. He oversaw the summer god, the season god, and the sixth lunar month moon god. As a subordinate of the Flame Emperor, he was responsible for an area of twelve thousand square li. He produced a legacy of eight different surnames, including that of the king of the state of Chu, whose subjects revered Zhurong as their ancestral paterfamilias.

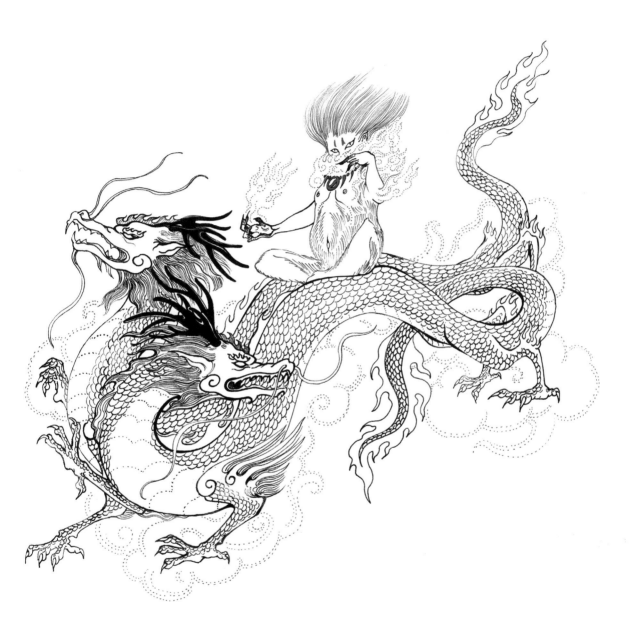

Western Lands
Beyond the Seas
海外西经

Xiahou Qi 夏后启

大乐之野，夏后启于此儛《九代》，乘两龙，
云盖三层。左手操翳，右手操环，佩玉璜。在
大运山北。一曰大遗之野。

There was a place called Dayi zhiye to the north of Dayun
shan, where Xiahou Qi, King Qi of the Xia dynasty, son of King
Yu, ascended heaven three times as a guest and saw a Nine
Generation Dance. He rode on two dragons and soared under a
canopy of three cloud layers. Pictured sometimes with a green
snake through each ear, in his left hand he grasped a splendid
parasol and in his right hand he held a jade ring; a precious
jade pendant hung from his waist. In heaven he obtained the
dances "Nine Disputes" and "Nine Songs," which he secretly
recorded and brought down to the mortal world, where they
were performed at Dayi zhiye. It was there that he first sang the
"Nine Beckonings."

Qigongguo 奇肱国

奇肱之国在其北。其人一臂三目，有阴有阳，乘文马。有
鸟焉，两头，赤黄色，在其旁。

Qigongguo was north of Yibiguo, 40,000 li from the Jade
Gate Pass of the Great Wall. The people there had one arm,
one eye, and one nostril, it is said. Their country was north
of the Land of Three-body People. The Qigong people also
had only one arm each, but three eyes, a bit of yin and a bit
more yang, with the yin eye above the two yang eyes. The
people rode pure white horses with a red mane and eyes that
flashed like gold. Their riders could live a thousand years,
making the steeds truly magical. A special two-headed bird
of prey perched behind them, with red and yellow coloring.
Though limited by the missing arm, the riders were experts at
making ingenious tools, some used to hunt and catch birds and
animals. They were also adept at making flying conveyances,
on which, according to legend, they were carried on the wind
during the reign of Tang of the Shang dynasty, all the way to
Yuzhou. When Tang learned of this, he ordered that the vehicle
be destroyed so that the common people could not see it. Ten
years later, during a great windstorm, Tang allowed the people
of Qigong Land to make another flying conveyance to carry
them home.

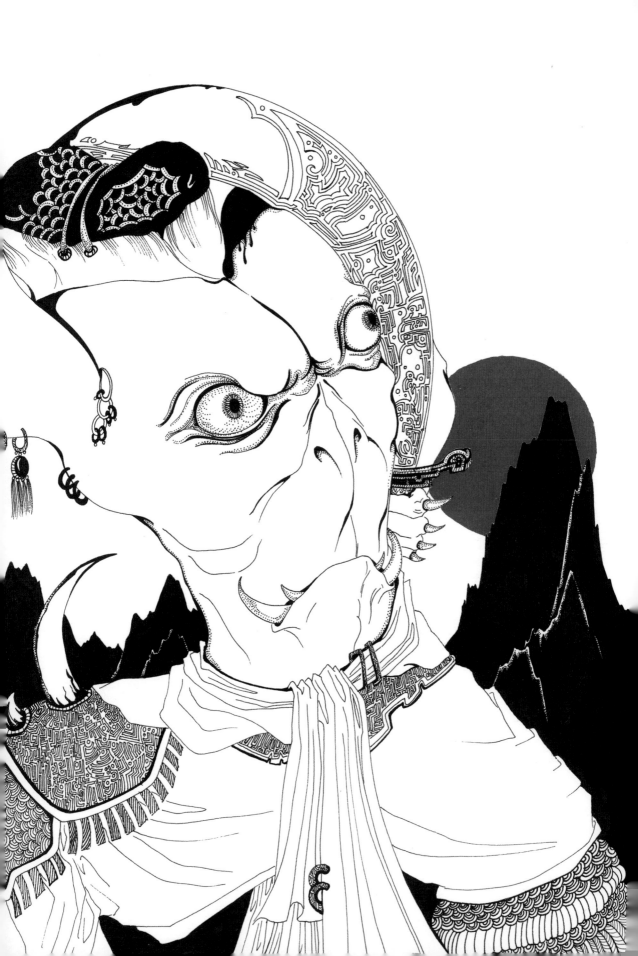

Xingtian 刑 天

刑天与帝至此争神，帝断其首，葬之常羊之山。
乃以乳为目，以脐为口，操干戚以舞。

The legend of Xingtian, the giant, has been passed down
through the ages. He tried to wrest power from the Lord
of Heaven, and when he was defeated, the Lord of Heaven
chopped his head off and buried it on Changyang shan. The
headless Xingtian did not die, as his nipples were turned into
eyes, his navel into a mouth. He continued fighting, with an ax
in one hand and a shield in the other. Though the outcome of
the battle has not been recorded, it is not difficult to reckon.
Some believe that Xingtian was one of the Flame Emperor's
officials, and that the Lord of Heaven, with whom he fought,
was the Yellow Emperor. In centuries that followed, Xingtian
was memorialized by poets, his heroic, unyielding spirit held
up as a model.

Bingfeng 并封

并封在巫咸东，其状如彘，前后皆有首，黑。

The Bingfeng, a bizarre animal resembling a wild boar, dwelled on the eastern edge of Wuxianguo. What distinguished it were the two heads, complete with tusks and mane, one on each end of the pitch-black body. There is no reference as to how it moved, though it must be assumed that some sort of coordination was required, as would be the case for any two-headed creature, including the rather more common two-headed snake. The poet and expert on ancient China, Wen Yiduo, considered such beasts as hermaphroditic, both male and female.

Xuanyuanguo 轩辕国

轩辕之国在此穷山之际，其不寿者八百岁。在女子国北。
人面蛇身，尾交首上。

Living in the vicinity of Qiong shan, the inhabitants of
Xuanyuanguo, situated north of the Land of Women, which
itself lay north of Shamen xian and was home to only two
women, all lived to the advanced age of 800 years or longer.
Though they had human faces and slim, feminine torsos, from
the waist down they had snakelike bodies that twisted upward
until the tips hovered just above their heads. The land may have
been the home of the Yellow Emperor Xuanyuan, which could
indicate that he too had a human face and the body of a snake.

Baimin chenghuang 白民乘黄

白民之国在龙鱼北，白身披发。有乘黄，其状如狐，其背上有角，乘之寿二千岁。

Inhabitants of the Land of White People, Baiminguo, north of where the ancient Long Yu fish dwelled, had long, flowing hair and bodies that were pure white. Another inhabitant of the land was a wild foxlike animal called the chenghuang, whose body was also white, its tail long and flowing, with short horns that protruded down its spine. Anyone who managed to climb onto the chenghuang's back and ride it was assured of living at least a thousand years, even to the age of three thousand.

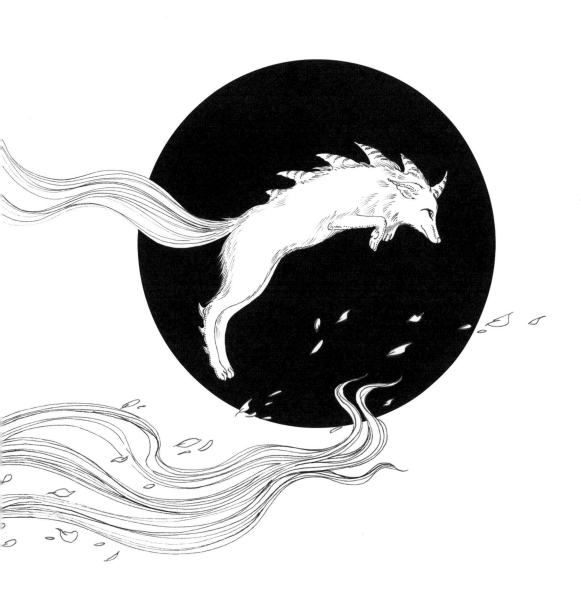

Northern Lands Beyond the Seas
海 外 北 经

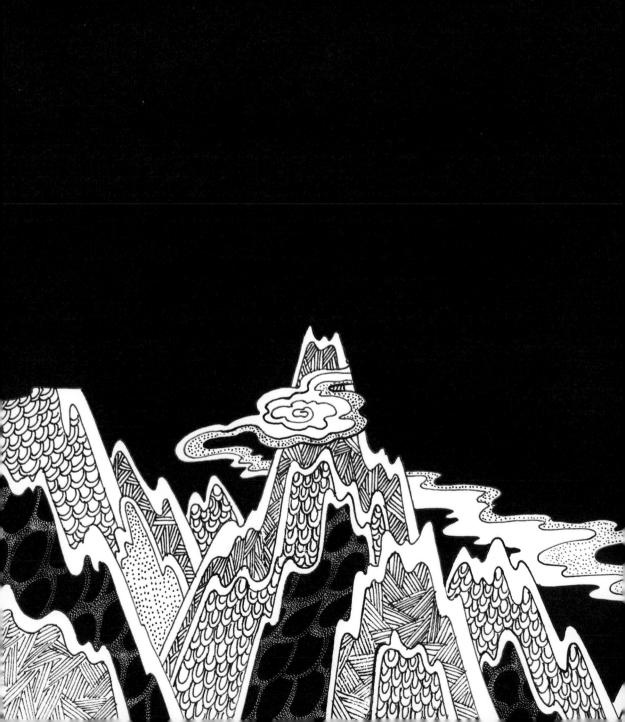

钟山之神，名曰烛阴，视为昼，瞑为夜，吹为冬，呼为夏，不饮，不食，不息，息为风，身长千里。在无启之东。其为物，人面，蛇身，赤色，居钟山下。

Zhuyin, also known as Zhulong, was the mountain god of Zhong shan. Its opened eyes brought daylight, its closed eyes created the darkness of night. Winter came when it exhaled, summer when it inhaled. It did not drink, it did not eat, nor did it breathe, for if it did, windstorms would follow. It was a thousand li long and dwelled on the eastern portion of the Land of Wuqi. It had a red snake's body but a forbidding human face. It resided in the Zhong shan foothills. It was associated with Pan Gu, the creator of heaven and earth, "whose tears created rivers, whose breath produced wind, whose voice was thunder, and whose eyes created lightning. On clear days it was happy, on gloomy days it was angry."

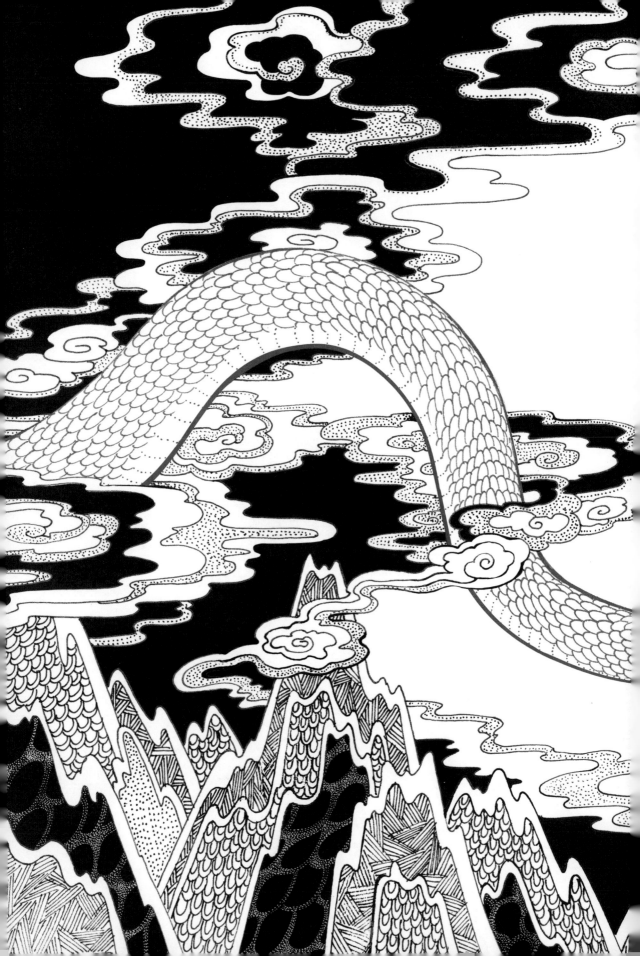

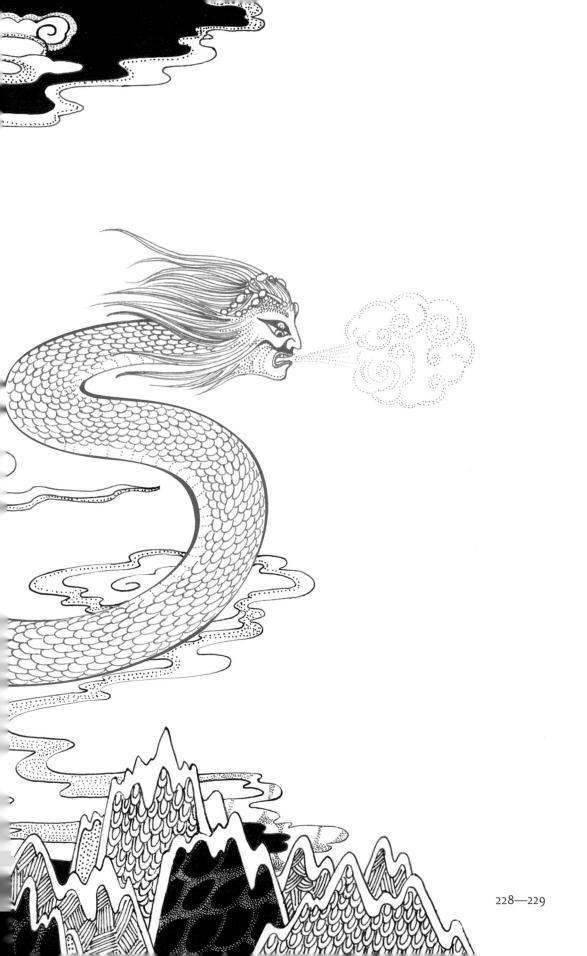

Rouliguo 柔利国

柔利国在一目东，为人一手一足，反膝，曲足居上。一云
留利之国，人足反折。

In the Land of Ruoli, east of Yimuguo, whose inhabitants had
only one eye in the middle of their faces, the dwellers were
humanoids with long braided hair, a single arm, and one leg.
Because they had no bones, their knees bent both ways and
their legs could bend all the way back, the foot pointing straight
up, even turning upside down.

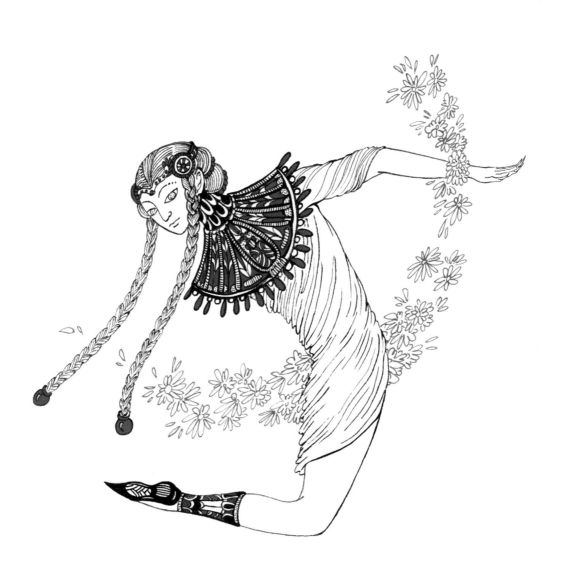

Xiang Liu 相柳

共工之臣曰相柳氏，九首，以食于九山。相柳之所抵，厥为泽谿。禹杀相柳，其血腥，不可以树五谷种。禹厥之，三仞三沮，乃以为众帝之台。在昆仑之北，柔利之东。相柳者，九首人面，蛇身而青。不敢北射，畏共工之台。台在其东。台四方，隅有一蛇，虎色，首冲南方。

The water god Gong Gong had an official named Xiang Liu, another snakelike creature, but one with nine heads, all with human faces, usually characterized as those of beautiful women. They consumed whatever was edible on nine mountains. Wherever Xiang Liu passed over, the land became marshland and could no longer produce the five grains. The Great Yu decided to kill Xiang Liu, whose blood flowed in many directions, leaving behind foul miasmas and barren earth. Yu tried to fill in the red streams, but they merely caved in and created deep culverts. After too many failed attempts, Yu used the excavated dirt to build a terrace for the many deities on the north face of Kunlun shan. It was square, with a snake at each corner. Rouliguo was on the eastern slope. No one dared to shoot an arrow northward, for fear of striking the terrace.

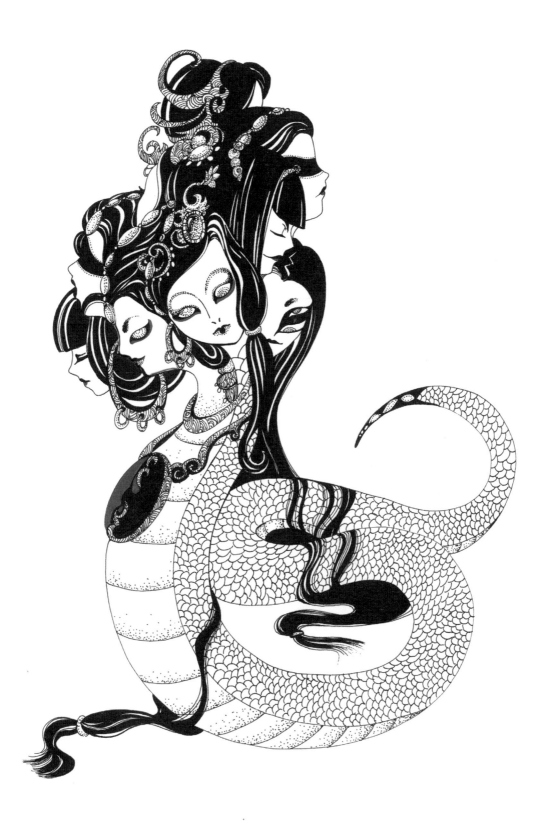

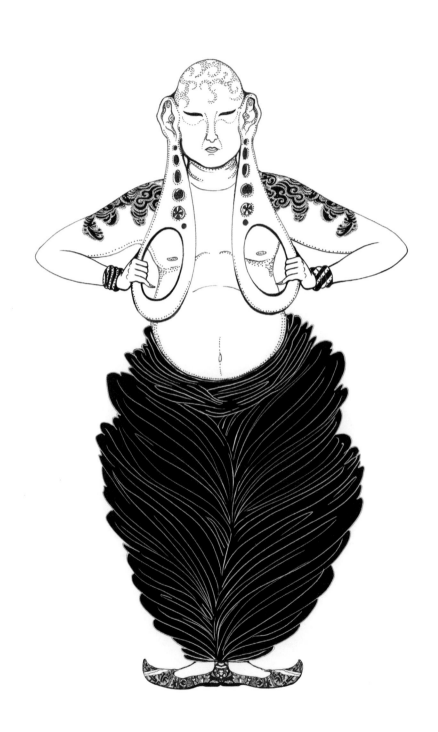

Nie'erguo 聂耳国

聂耳之国在无肠国东，使两文虎，为人两手聂其耳。县居
海水中，及水所出入奇物。两虎在其东。

Nie'erguo was situated on a lonely ocean island east of
Wuchangguo, the Land of People with No Intestines. All sorts
of strange creatures emerged from the surrounding waters. The
inhabitants of the island, said to be the sons of the ocean god,
had earlobes so long they drooped down to their chests. Most
of the time, they held the lobes up with their hands. They were
endowed with the power to control two striped tigers.

Kuafu 夸父

夸父与日逐走，入日。渴欲得饮，饮于河渭，河渭不足，
北饮大泽。未至，道渴而死。弃其杖。化为邓林。

Kuafu chasing after the sun was a tale known to members of
all households. Kuafu chased it the all the way to Yu Gu, where
the sun set, and was so parched he drained the waters of the
Yellow River and the Wei River. His thirst still unquenched, he
headed north for the Great Marsh, but died of thirst without
reaching it. Before he breathed his last, he flung his cane away,
and a vast peach orchard, three hundred li in size, sprang up
where it landed. Kuafu was a popular figure in Chinese literary
tradition, mentioned often for his benevolent act in the service
of later generations, and memorialized in verse by poets as
celebrated as Tao Yuanming. His legacy was one of a minister
who retains his loyalty and high-minded attitude even in the
face of failure.

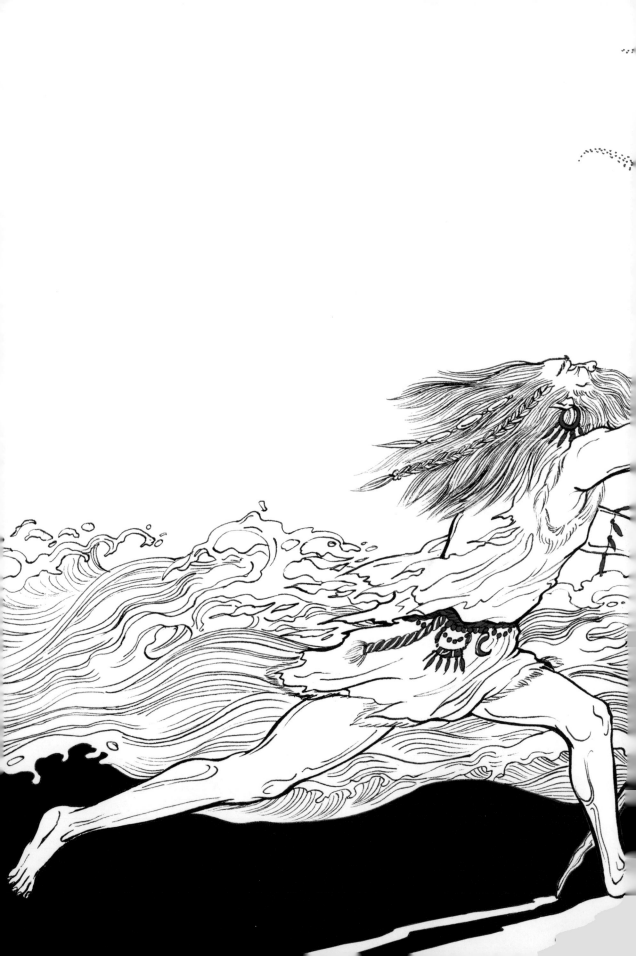

Yuqiang 禺 强

北方禺强，人面鸟身，珥两青蛇，践两青蛇。

Yuqiang, god of the northern sea, who was in charge of winter, was thought to be the son of the god of the eastern sea. He was sent to assist Zhuan Xiang in governing the north. He had a bird's body and an old man's face, with pierced ears, from which hung two colorful snakes. He stood atop two much larger snakes and has been identified as a wind-riding god as well. When he appears as a god of wind, he has human hands and feet but a bird's body.

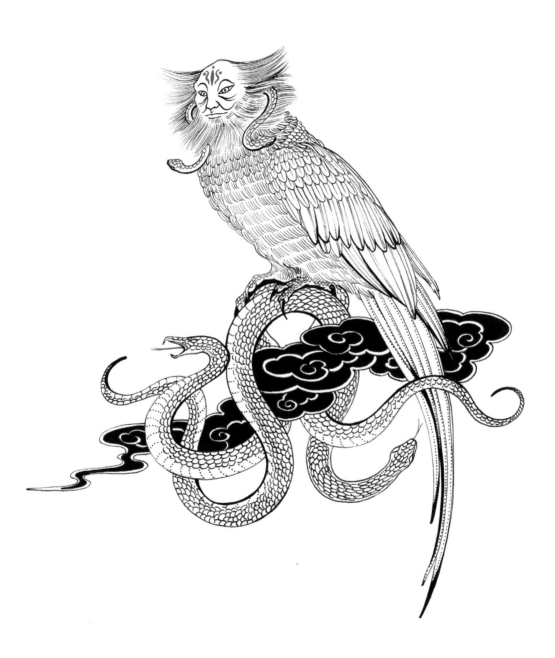

Eastern Lands
Beyond the Seas
海 外 东 经

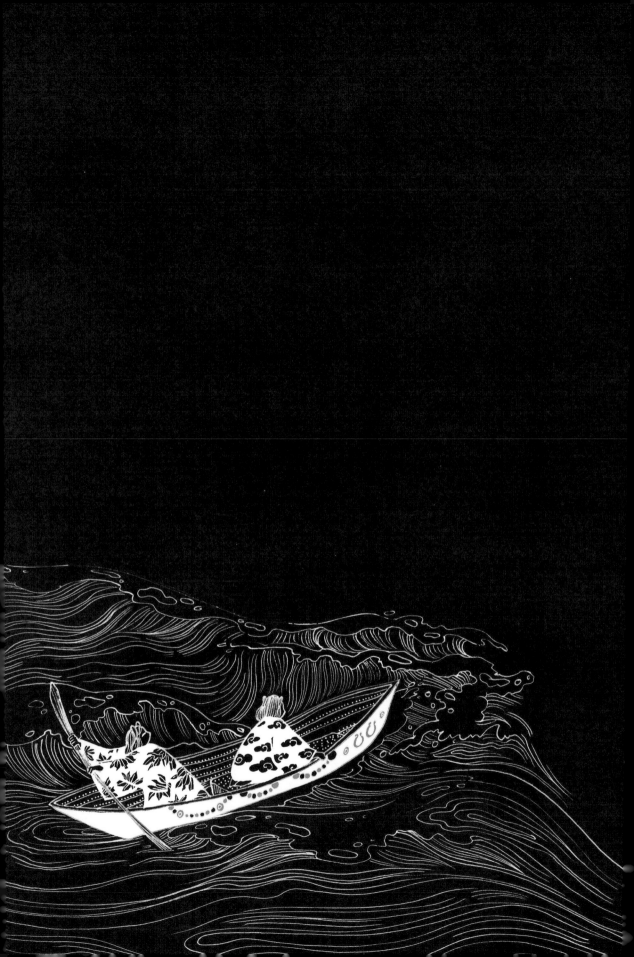

Darenguo 大人国

大人国在其北，为人大，坐而削船。一曰在蹉丘北。

The actual location of Darenguo has never been determined. What is known is that it was a land of giants, men who were seen rowing boats on waters sharing the waves with boatmen of normal size. Encounters were not recorded. With a gestation period of thirty-six years, by the time the young giants were born, their parents' hair had already turned gray. The newborns were very large, of course, and were immediately capable of riding the clouds and flying on mist, but were incapable of walking on earth. That was because, as some people believed, although they were creatures with the faces and bodies of humans, they were actually dragons in human form.

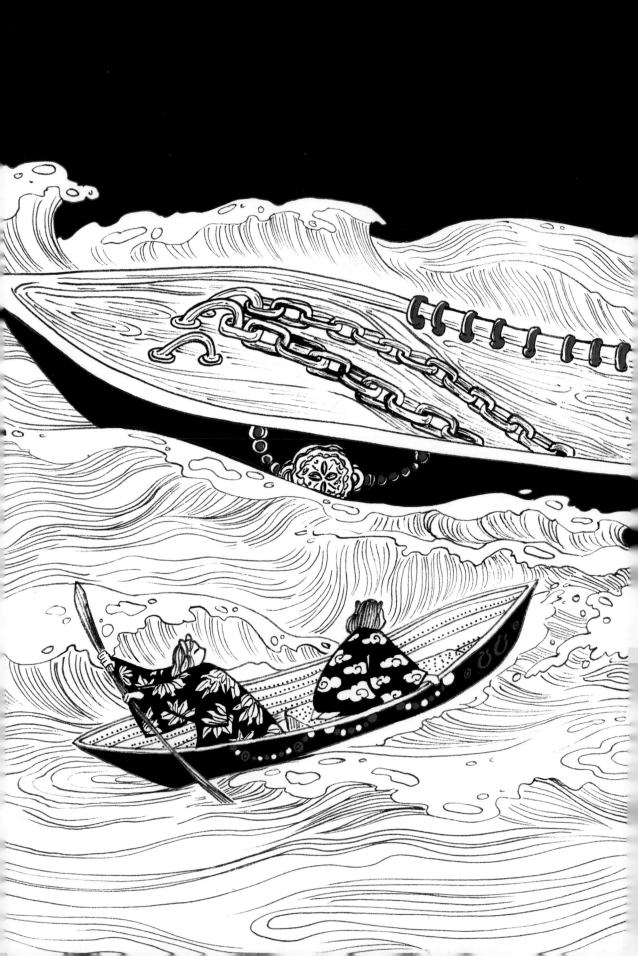

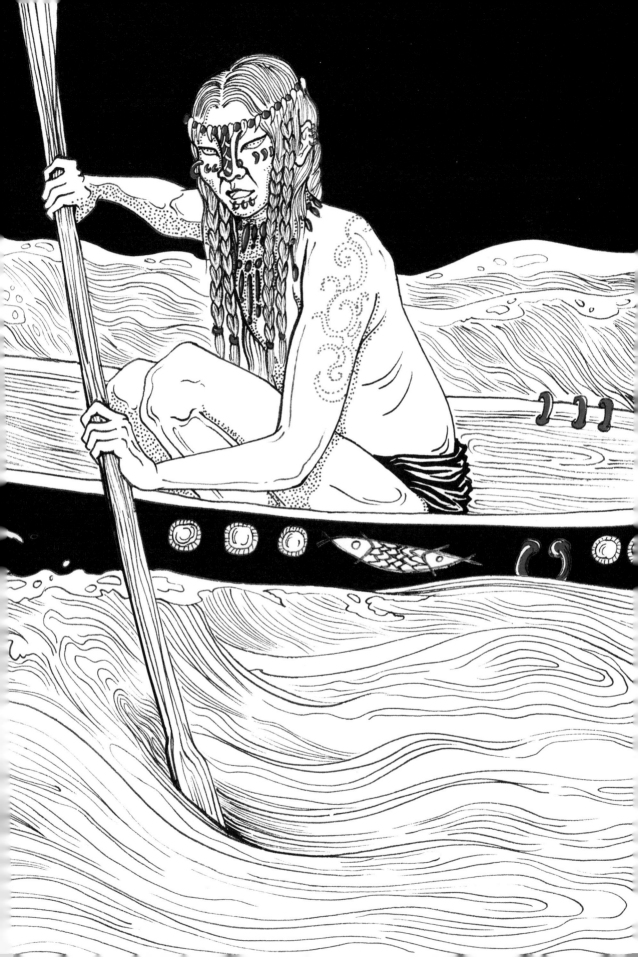

Shebishi 奢比尸

奢比之尸在其北，兽身、人面、大耳，珥两青蛇。

The Corpse of Shebi lies north of the Land of Giants. Shebi
is the Shelong, or Dragon, a creature with the body, tail, and
claws of a fierce feline, the face of a human, but with intense
eyes, a horn emanating from just above its snout, and enlarged
ears from which snakes dangle. It is one of the stranger gods
in the compilation, and for unknown reasons, it was killed by
a superior god. Its spirit, however, was not exterminated and
continued to live in the form of a corpse.

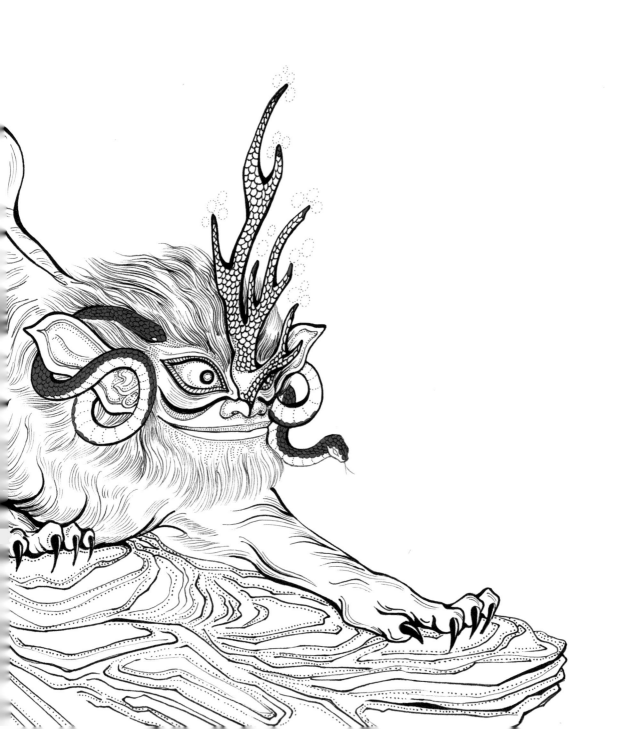

Junziguo 君子国

君子国在其北，衣冠带剑，食兽，使二文虎在旁，
其人好让不争。有薰华草，朝生夕死。

Junziguo, the Land of Gentlemen, lay north of Shebishi. Its
inhabitants dressed and acted like gentlemen, with ornamental
swords at their waists. They feasted on wild animals but
controlled and were waited on by ferocious striped tigers that
never left their side. Dressed in long, formal robes, with ornate
headdresses, they were civil, modest, and courteous, studiously
avoiding disputes, gentlemen in every sense of the word. The
country was also home to a plant with flowers that bloomed
in the morning and withered in the evening, like the common
morning glory.

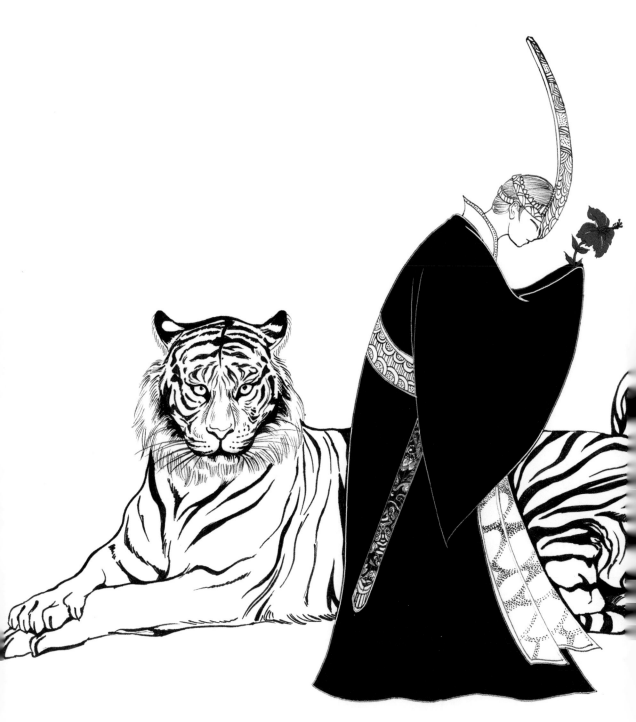

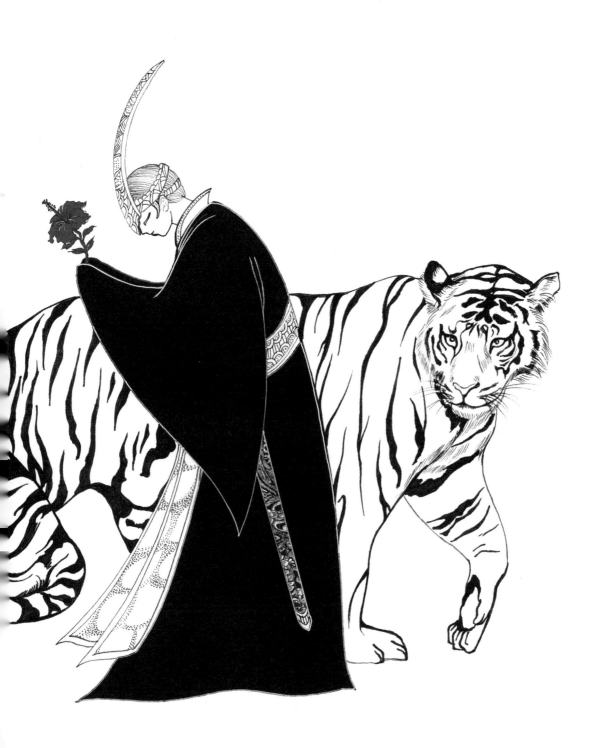

Tianwu 天吴

朝阳之谷，神曰天吴，是为水伯。在蛮蛮北两水间。其为兽
也，八首人面，八足八尾，背青黄。

Tianwu, otherwise known as the legendary Shuibo, god of
the waters, dwelled in Chaoyang Valley. His home was a spot
between two rivers north of the double rainbow. He cut a
freakishly strange figure, with two pairs of legs that did not
reach the ground midway between the two joined parts of the
torso. Those appendages functioned as hands, while the front
and back feet resembled those of a human. Tianwu had six
non-prehensile tails and eight heads, with different humanoid
faces, facing in all eight directions—north, south, east, west,
northeast, southeast, northwest, and southwest. Its origins
and ancestry are too complex to be imagined, its look hideous
beyond belief, its powers enormous.

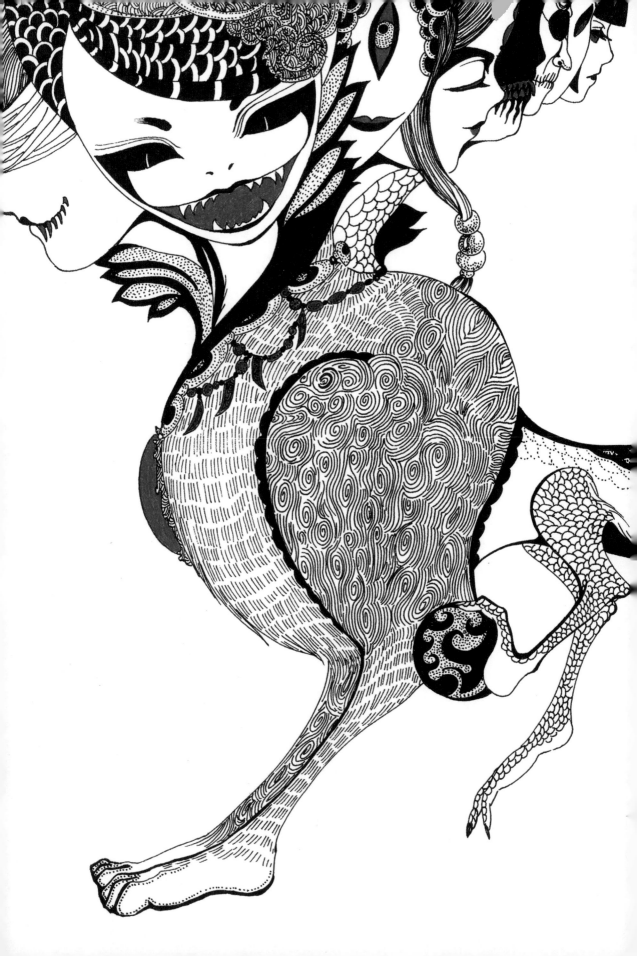

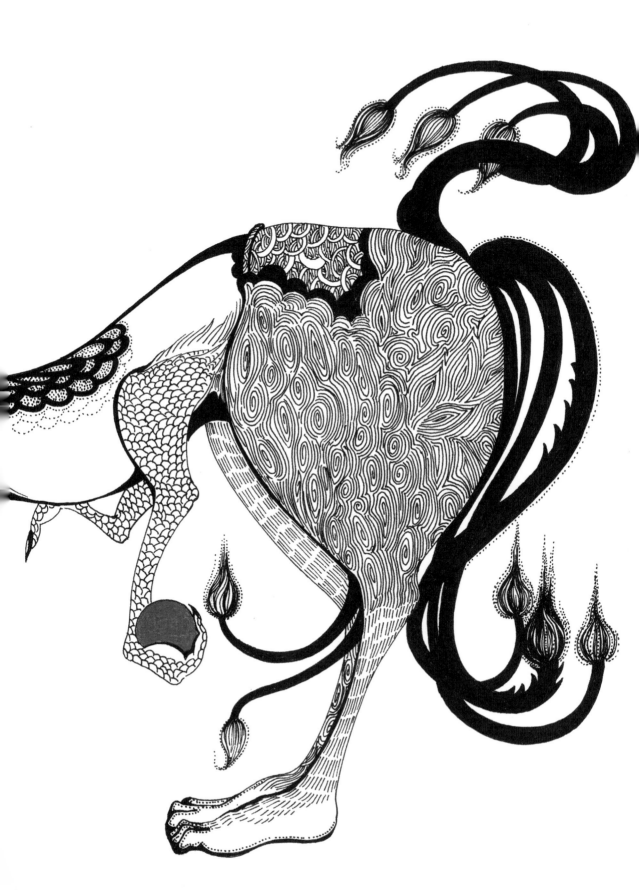

Shuhai 竖亥

帝命竖亥步，自东极至于西极，五亿十选九千
八百步。竖亥右手把算，左手指青丘北。一曰
禹令竖亥。一曰五亿十万九千八百步。

The Lord of Heaven ordered the fast-walking god Shuhai
to pace off the size of the land. From east to west, he took
500,109,800 paces. Holding a counting rod in his right hand,
he pointed with his left hand to the northern edge of the land
of Qingqiu. Other sources contend that the order was given not
by Tian Di but by Yu the Great, who tamed the floods. There is
no consensus among later chroniclers regarding the number of
paces taken or the distances covered, and many of the estimates
seem utterly baseless.

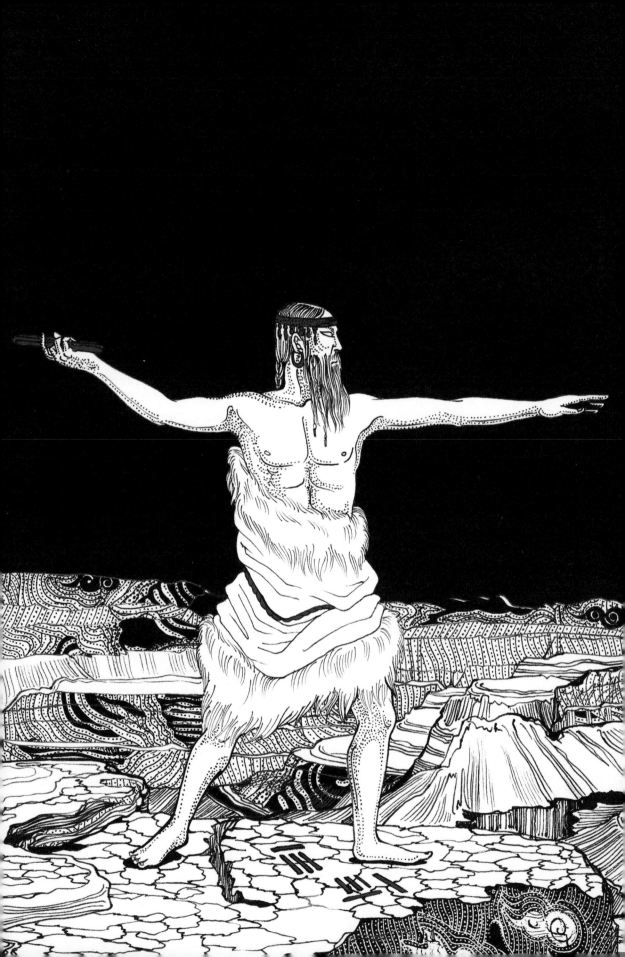

Fusang shu 扶桑树

下有汤谷。汤谷上有扶桑，十日所浴，在黑齿北。
居水中，有大木，九日居下枝，一日居上枝。

There was a mountain valley north of Heichi Guo called Yang
Gu. It was where ten suns went to bathe, naturally turning the
water there boiling hot. A mulberry tree, the Fusang shu, stood
in the water at the edge of the valley. Another giant tree was
where nine suns rested on the lower branches and one on an
upper branch. They changed places on a rotating basis every
day.

Yushiqie 雨师妾

雨师妾在其北。其为人黑，两手各操一蛇，左
耳有青蛇，右耳有赤蛇。一曰在十日北，为人
黑身人面，各操一龟。

Some believe that Yushiqie was the name of a nation or a
tribe, though others insist that she was the rain god Ping Yi's
concubine, a creature with a human face. But if the former is
true, then the land of Yushiqie lay to the north of Yang Gu. The
bodies of the people there were covered in black, with a snake
in each hand and two more in their ears, each a different color.
Some have opined that the land of Yushiqie was where the ten
suns were located.

Southern Lands
Within the Seas
海 内 南 经

Si 兕

兕在舜葬东，湘水南。其状如牛，苍黑，一角。

A ferocious animal called a Si lived on the southern bank of the Xiang River, just east of the burial site of the legendary ruler Shun. Built like a modern-day rhinoceros, it had a jet-black hide and a single horn that curved back from its forehead. It weighed at least a thousand jin. Reports exist that many more Si lived in other ancient lands. Their hides, when made into armor, could last two hundred years and were awarded to the fiercest fighters.

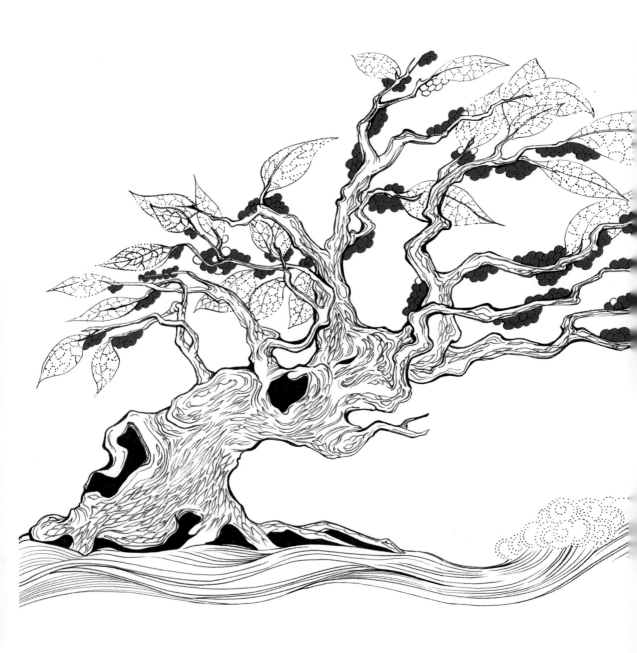

Jianmu 建木

有木，其状如牛，引之有皮，若缨、黄蛇。其
叶如罗，其实如栾，其木若苈，其名曰建木。
在窫窳西弱水上。

There once existed a tree that resembled an ox. Its
bark peeled off like the tassel band on a cap or the
skin of a yellow snake. The leaves, which were dark
green, looked like snares; its yellow fruit was similar
to jujubes. The purple trunk resembled a prickly
elm. Its name was Jianmu. It grew on the banks
of the Ruo River on the western edge of a place
called Yayu. It existed in a spot between heaven and
earth, where the shadows of people standing in its
shade disappeared and their voices became mute.
On their way to the world below, the gods used the
Jianmu as a ladder.

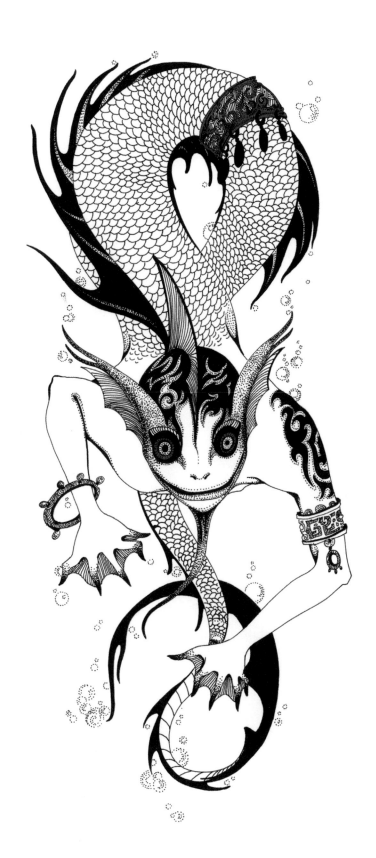

Diren 氐人

氐人国在建木西，其为人人面而鱼身，无足。

The Land of Diren was west of the Jianmu tree. The inhabitants had legless, scaly fish bodies, webbed fingers, and human heads and faces, with fins on the top and sides. They were descendants of the Flame Emperor; their most immediate ancestor was the emperor's grandson Ling Jia. Despite being half human, half fish, they had no trouble navigating the space between heaven and earth.

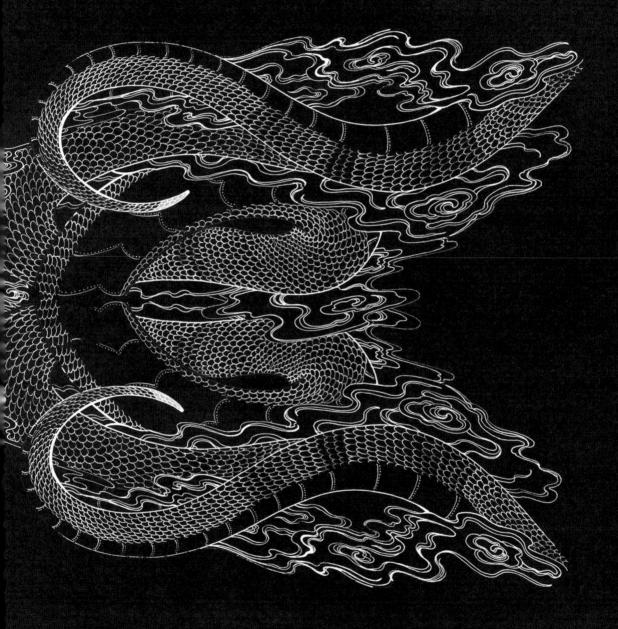

Bashe 巴蛇

巴蛇食象，三岁而出其骨，君子服之，无心腹之
疾。其为蛇青黄赤黑。一曰黑蛇青首，在犀牛西。

Bashe, which had a variety of names, was a member of the boa
family, one so large it could swallow an elephant and spit out
its bones three years later. Tales of this elephant-swallowing
reptile appeared often, including by people who feasted on a
Bashe and were cured of heart and stomach illnesses. Its skin
merged many colors—green, yellow, red, black—though some
descriptions colored it black with a green head, perhaps even
a red-tipped tail. It had all the physical qualities of a snake,
including the ability to frighten even the boldest human. This
particular reptile represents the origin of the common saying to
characterize a greedy person—a snake ingesting an elephant.

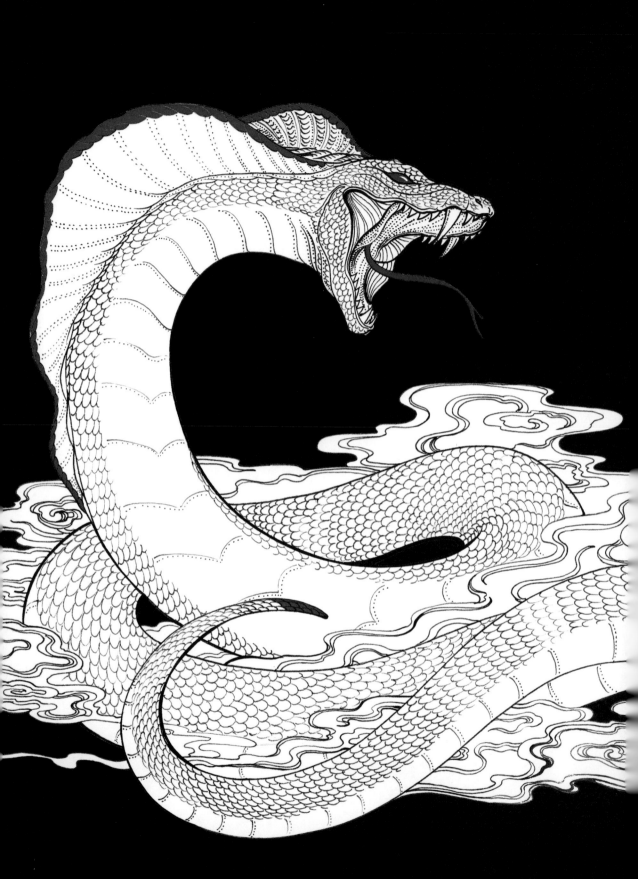

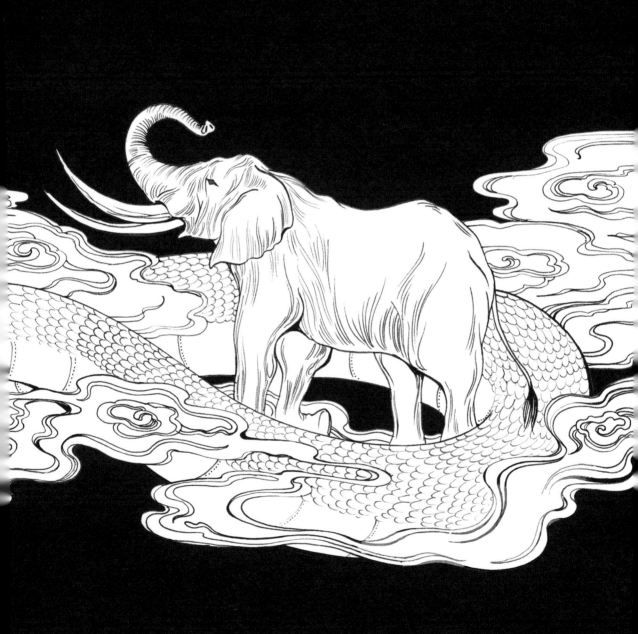

Meng Tu 孟涂

夏后启之臣曰孟涂，是司神于巴。人请讼于孟涂之所，其衣有血者乃执之。是请生，居山上，在丹山西。丹山在丹阳南，丹阳巴属也。

King Qi of the Xia dynasty had a palace official named Meng Tu, a god in charge of litigation in the place called Badi. The term "god" was often applied to nobility during ancient times. When people from Badi went to him to lodge a complaint, Meng would arrest whoever had bloodstains on their clothes, since the ancients believed that a liar would be stained. As unscientific as it may appear to us, Meng was considered compassionate for his effort to spare the innocent. He lived on a mountaintop west of Dan shan, which was south of Danyang, thought to be Wu shan in present-day Sichuan.

Western Lands
Within the Seas
海 内 西 经

Erfu zhi Chen yue Wei 贰 负 之 臣 曰 危

贰负之臣曰危，危与贰负杀窫窳。帝乃梏之疏
属之山，桎其右足，反缚两手与发，系之山上
木。在开题西北。

Erfu was a god with a snake's body and a human face. Together with an official of his named Wei, he killed another god named Yayu. That enraged the Lord of Heaven (some say it was the Yellow Emperor), who ordered the confinement of Wei on Shushu shan, northwest of Kaiti Guo, where he was shackled to a large tree by his right foot and cuffed behind his back with his own hair. Thousands of years later in the Later Han period, during the reign of the Xuan Emperor, someone who was carving into rocks found inside a stone cellar a barefoot man who fit the description of the imprisoned Erfu. He was then sent to the capital city of Chang'an. The emperor asked his ministers about the man's identity. No one could produce the answer, no one but Liu Xiang, who cited *The Classic of Mountains and Seas*, making it an instantly popular book to study.

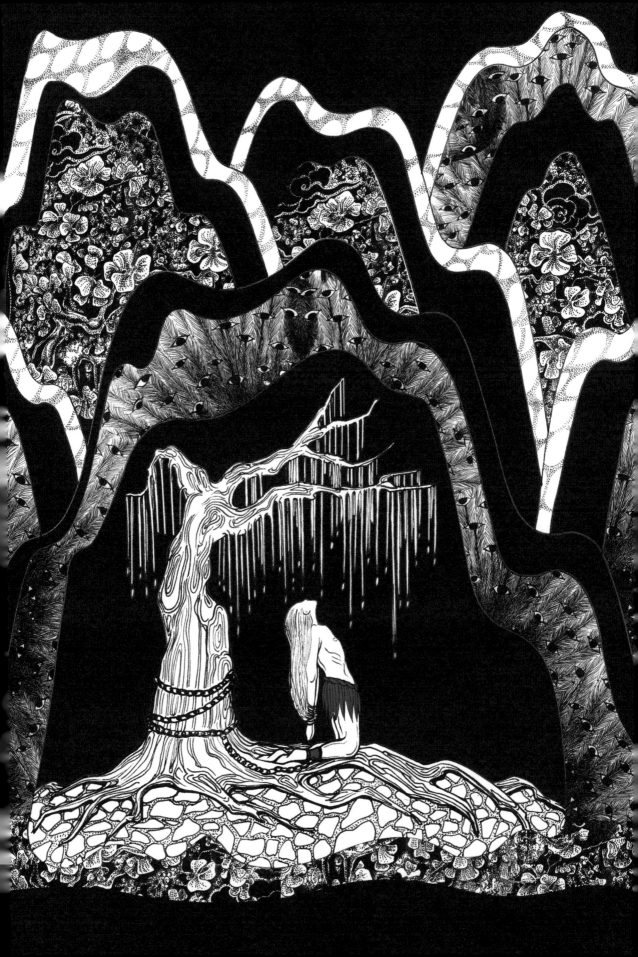

Kaimingshou 开明兽

昆仑南渊深三百仞。开明兽身大类虎而九首，皆人面，
东向立昆仑上。

There was a trench on the southern slope of Kunlun shan
three hundred ren deep. The guardian of the mountain was
a ferocious-looking beast called the Kaimingshou. With the
look of a tiger, a very large one, it had nine heads, each with a
human face, all scowling in different directions, some bearded,
some not, all fanged. The central head looked east from where
it stood on the mountain.

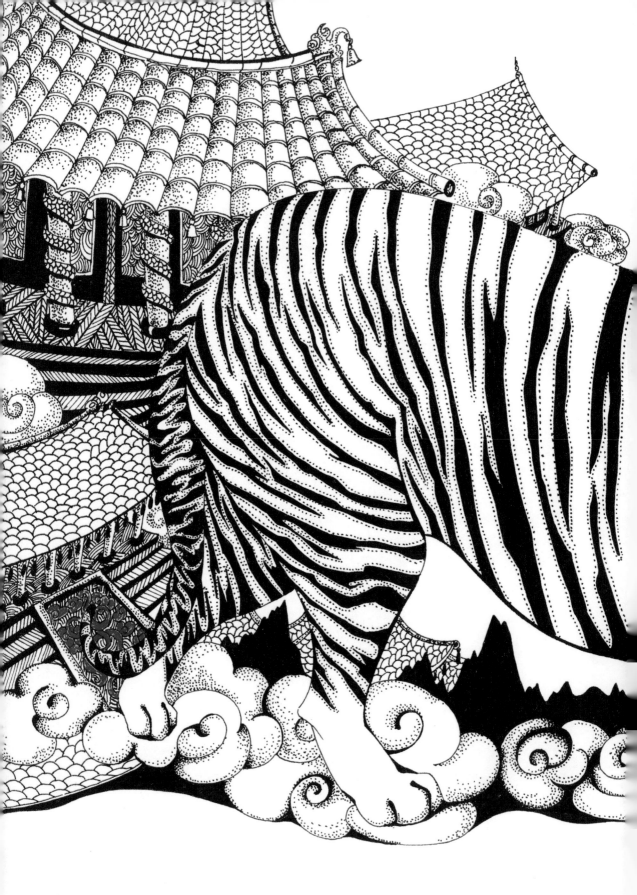

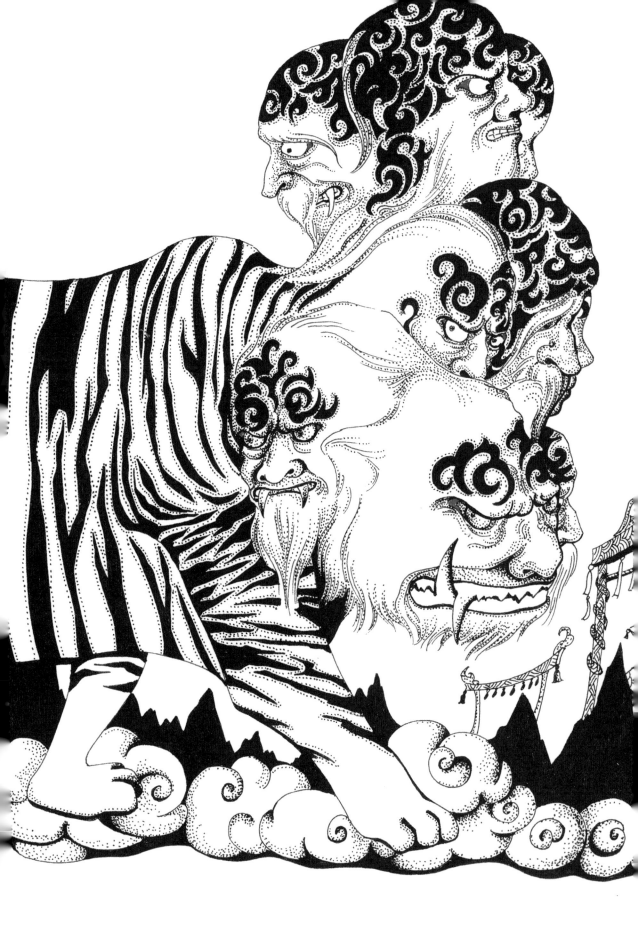

Northern Lands Within the Seas
海内北经

San qingniao 三青鸟

西王母梯几而戴胜杖，其南有三青鸟，为西王
母取食。在昆仑虚北。

On the northern side of Kunlun shan, three valiant, high-flying birds with red beaks, prominent black plumes with a wide wingspan, and white bodies searched for food. They did this not for themselves but for the Queen Mother of the West, who wore a jade headdress as she leaned against a table and waited. Their activity, their very presence, was considered sacrosanct by the people below. Their names were Dali, Xiaoli, and Qingniao.

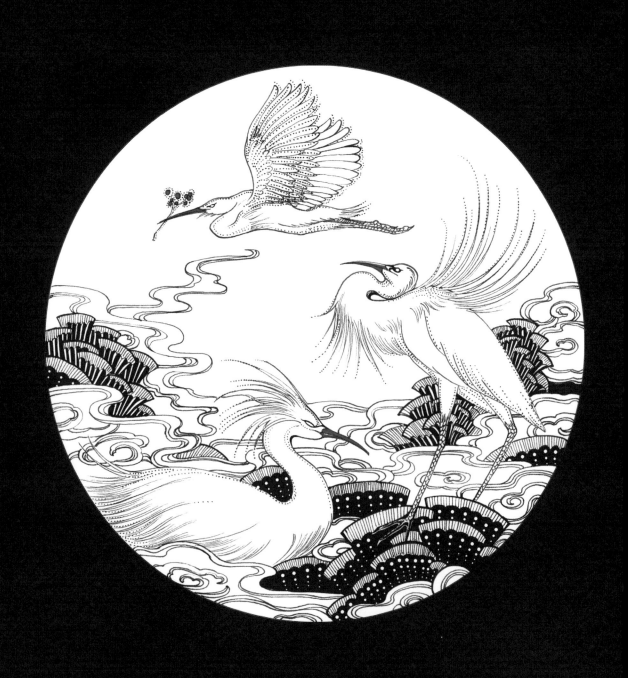

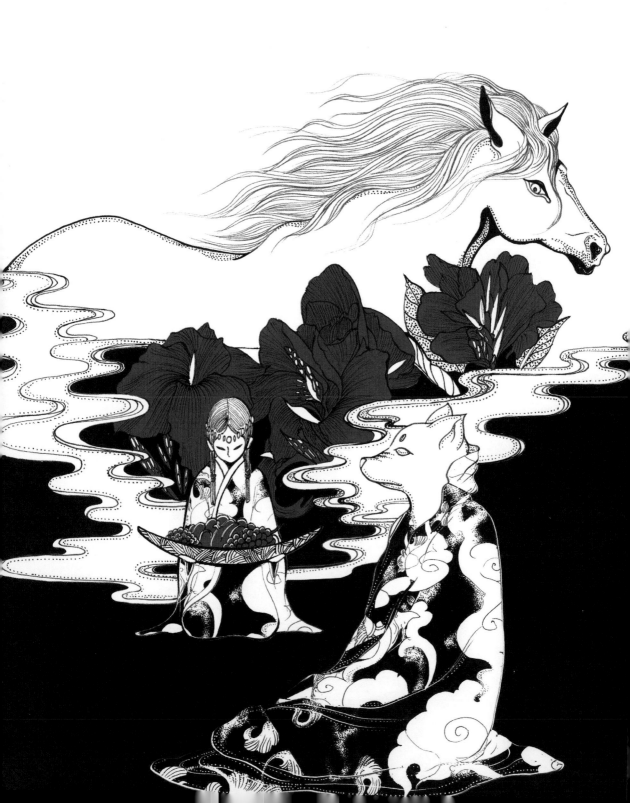

Quanfengguo 犬 封 国

犬封国曰犬戎国，状如犬。有一女子，方跪进
杯食。有文马，缟身朱鬣，目若黄金，名曰吉
量，乘之寿千岁。

Quanfengguo was east of Jianmu, on the western slope of
Kunlun shan. There is no unanimity regarding the origins
of the country, reaching back into antiquity, though the
most popular myth relates the issue of a country from the
mating of two white dogs. The men of the country had canine
bodies, head to tail. Legend has it that the women were all
born with pretty faces, and in images passed down from
ancient times, they waited on their husbands as if they were
kings and emperors. The tradition endured through history.
Quanfengguo was known for its horses, all pure white with a
flowing mane and eyes that sparkled like gold. Anyone who
rode one would live for a thousand years.

Wa 袜

袜，其为物人身、黑首、从目。

The Wa was a goblin in human form. It had a black head and vertical eyes. It was a frightful evil spirit. In ancient times, deities that specialized in consuming demons sought to rid the world of Wa goblins by eating them. They were controlled but never eradicated, as is true with all evil spirits.

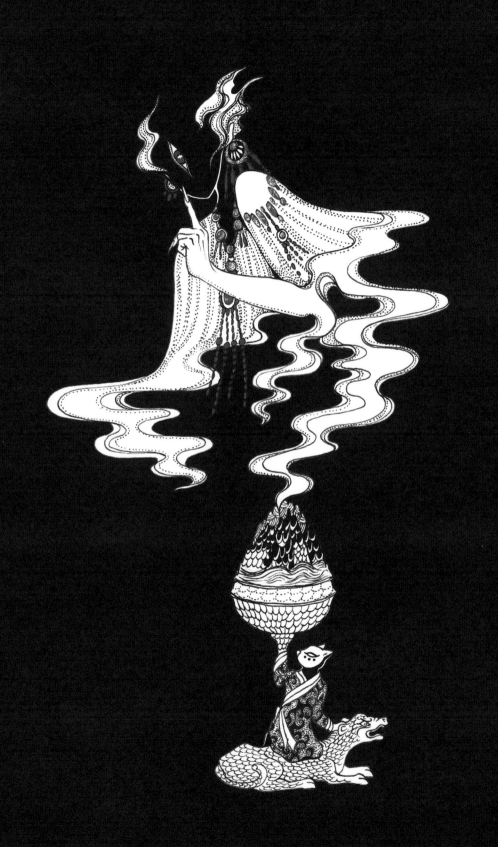

Daxie 大蟹

大蟹在海中。

A legendary race of giant crabs that grew to a thousand li was said to live in the ocean. They were too big to kill, let alone eat, and were voracious scavengers, in and out of the water. There is no known link to the seagoing giants whose enormous size dwarfed all humans and other creatures that fished the ocean, a thought worthy of speculation.

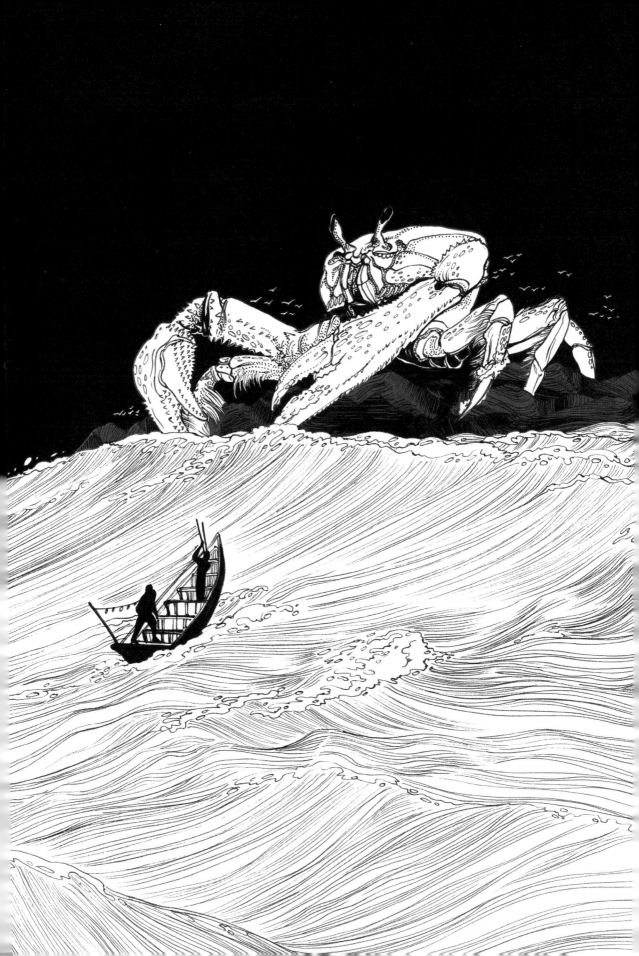

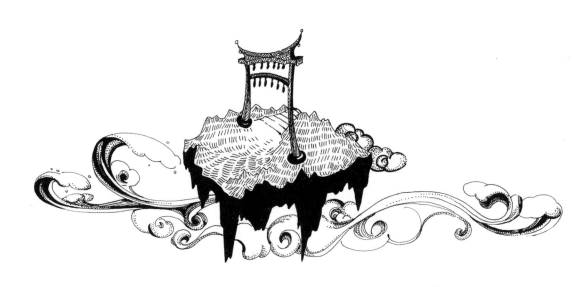

Penglai 蓬萊

蓬萊山在海中。

Fabled Penglai shan was located in the ocean and was one of three divine islands, the others being Fangzhang and Yingzhou. The palace there was replete with gold and jade, and all the wildlife—birds and beasts—were white, from head to toe. Seen from a distance, they formed to make it look like a sky full of clouds hanging above the mountain peak. The island grew in importance over the centuries, with many expeditions sent to locate it. None was successful, and Penglai became a center of Taoist religious beliefs.

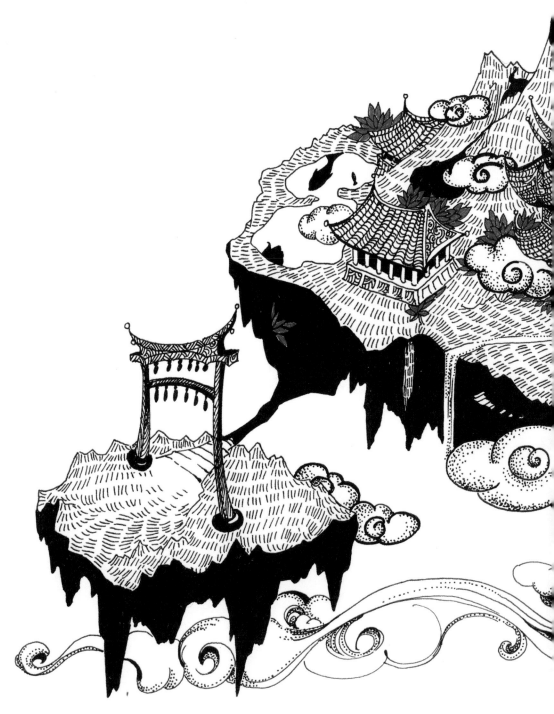

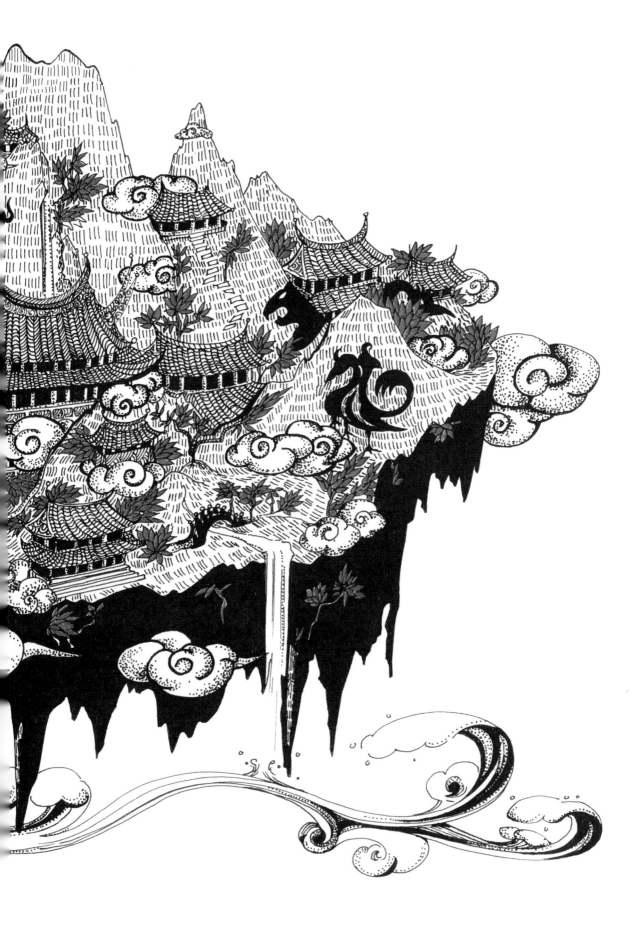

Eastern Lands
Within the Seas
海 内 东 经

Leishen 雷神

雷泽中有雷神，龙身而人头，鼓其腹。在吴西。

A dragon with a human face that dwelled in Leize, a place west of Wu, produced thunder by striking its own midsection. Known as the god of thunder, it had no unusual physical attributes, except that it was a dragon.

Xiaorenguo 小人国

有小人国，名靖人。

The inhabitants of Xiaorenguo, the Land of Little People, were called Jingren, tiny folk. They were said to be no more than nine inches tall. Their country was near the Land of the Giants.

Wang Hai 王亥

有困民国，勾姓而食。有人曰王亥，两手操
鸟，方食其头。王亥托于有易、河伯仆牛。有
易杀王亥，取仆牛。河伯念有易，有易潜出，
为国于兽，方食之，名曰摇民。帝舜生戏，戏
生摇民。

The inhabitants of Kunminguo shared the same surname—
Gou. Their staple food was millet. A man named Wang Hai,
the first ruler of the Yin Shang era, caught a bird in his hands
and proceeded to eat its head. He entrusted a herd of fat oxen
to the ruler of the Youyi tribe, Mian Chen, and the river god
He Bo. Mian Chen killed Wang Hai to seize the herd for
himself. The new ruler of the Shang clan, Shangjiawei, sent
soldiers to seek revenge by killing most members of the Youyi
tribe. He Bo lamented their deaths and helped the surviving
members flee to a territory with wild fauna, where they
established a new country and fed on the wild animals. They
were called Yao People.

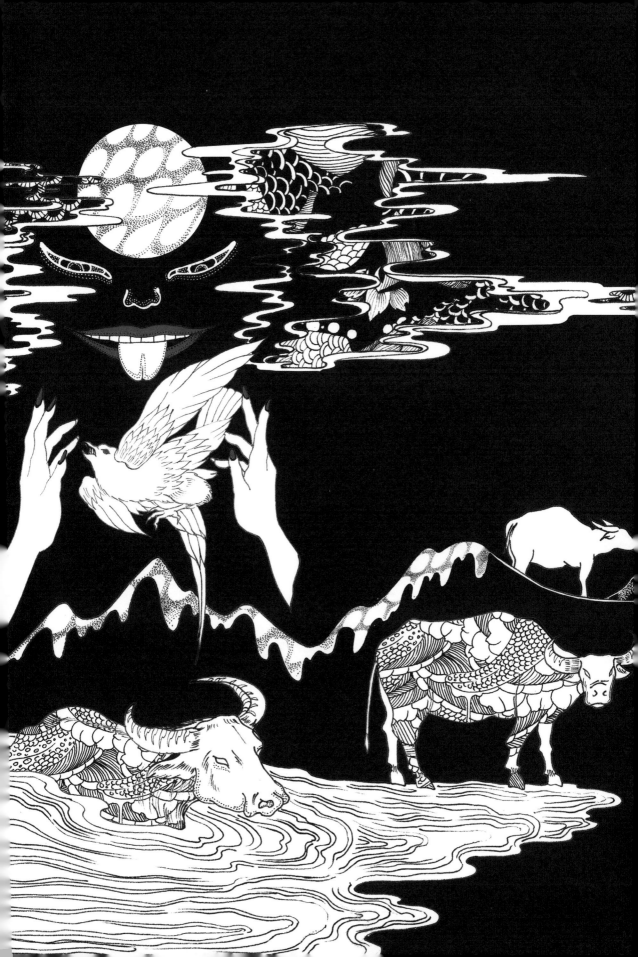

大荒东北隅中，有山名曰凶犁土丘。应龙处南
极，杀蚩尤与夸父，不得复上。故下数旱，旱
而为应龙之状，乃得大雨。

A dragon called Yinglong lived on the southern flank of a
mountain named Xiongli Hill in the northeast corner of the
Great Wasteland. As the Yellow Emperor's personal dragon, it
once helped the Great Shun prevent floods. The dragon had
wings and was the most magical of dragons, having killed
celestial beings Chiyou and Kuafu, who chased the blazing sun
to ease the misery of the people below and whom others said
died of thirst. For this, Yinglong could not return to heaven.
With no Yinglong, who created clouds and rain, the people
below suffered constant droughts. When that happened, they
masqueraded as Yinglong or fashioned clay images of the
dragon to bring rain, often successfully.

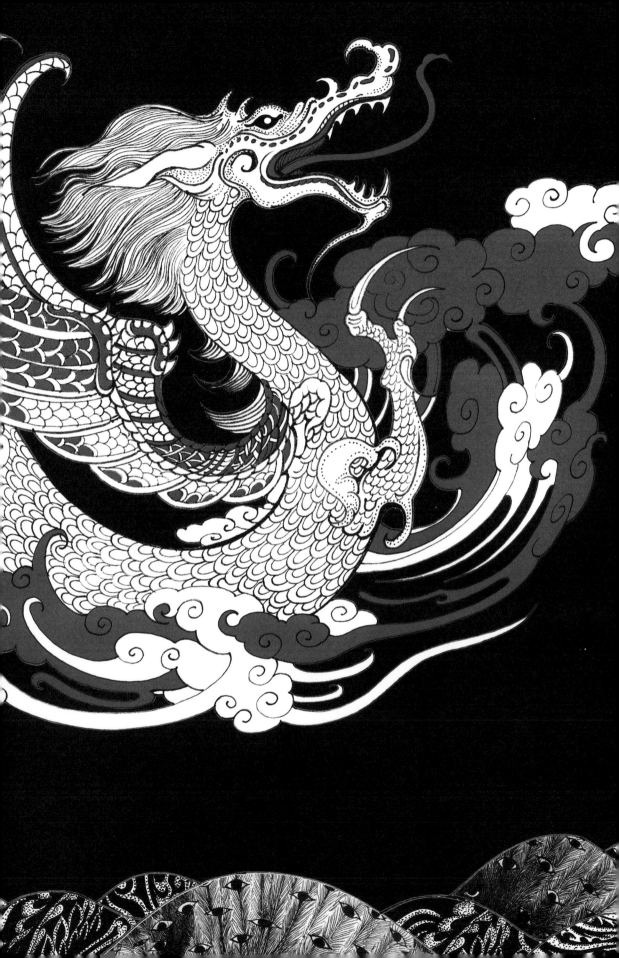

Kui 夔

东海中有流波山，入海七千里。其上有兽，状
如牛，苍身而无角，一足，出入水则必风雨，
其光如日月，其声如雷，其名曰夔。黄帝得
之，以其皮为鼓，橛以雷兽之骨，声闻五百
里，以威天下。

The mountain Liubo shan, seven thousand li into the Eastern
Sea, was home to a strange bovine called Kui. Though it had
the body of a cow, the Kui had no horns and only one leg.
Whenever it entered and left the ocean, wind and rainstorms
followed. Its sleek hide gave off shimmering light; its call was
thunderous. The Yellow Emperor used the hide of a Kui for a
drumhead, which he beat with a bone from the thunder god.
Audible for five hundred li, it inspired terror throughout the
land.

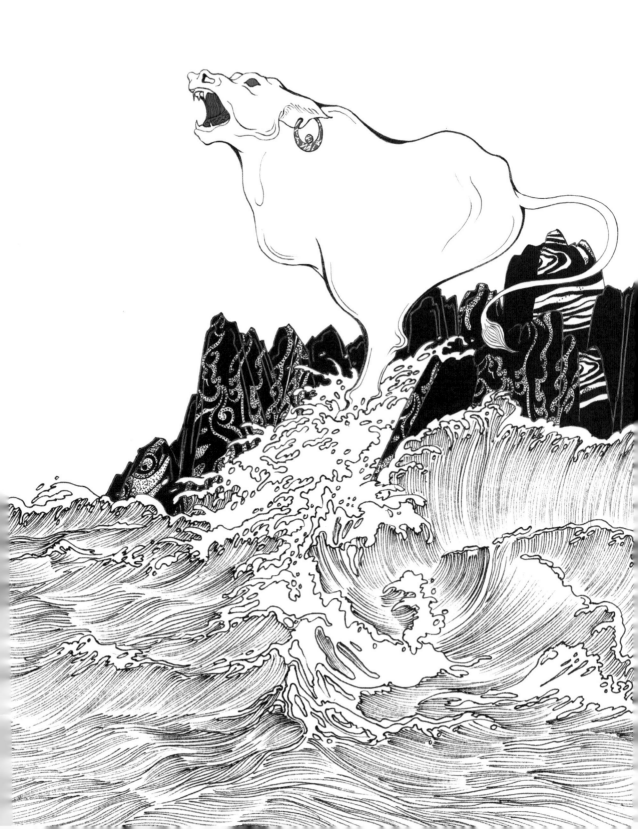

Great Southern Wastelands

大荒东经

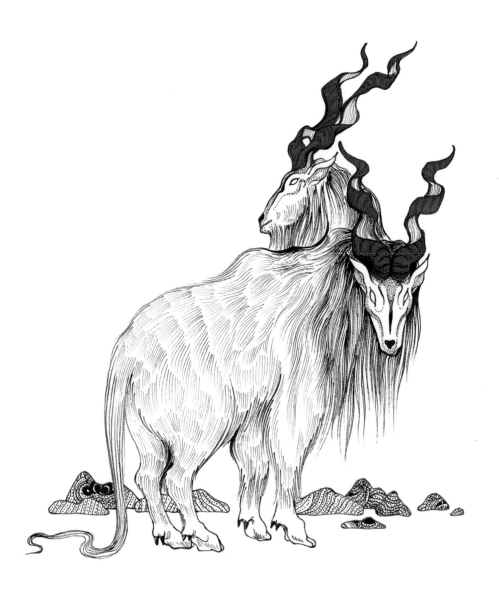

Chuti 跦 踢

南海之外，赤水之西，流沙之东，有兽，左右有首，
名曰跦踢。

A creature called the Chuti, with a body resembling a present-day yak, had two goatlike heads, one on the left, looking backward, and one on the right, looking forward, both with spiraling horns. Its hooves had cleatlike appendages that helped it safely navigate rocky ledges. The Chuti dwelled beyond the Southern Sea, west of the Chi River and east of Liusha. It was one of several multi-headed creatures in ancient times.

Luanmin 卵民

有卵民之国，其民皆生卵。

In the Land of Luanmin, all the residents laid eggs, from which their offspring were born. Once the eggs were laid, a male wrapped his body around the future offspring throughout the gestation period, surviving for months on stored fat. The female then relieved the slimmed-down male, to feed the newborn.

Xihe 羲和

东南海之外，甘水之间，有羲和之国。有女子名曰
羲和，方浴日于甘渊。羲和者，帝俊之妻，生十日。

Beyond the Southeast Sea where the Gan River flows, there was
a land known as Xiheguo. A woman of Xiheguo was one of the
wives of Dijun, the god whom some believe bestowed the bow
and arrow on Yi the archer. She bore Dijun ten suns, whom she
was seen bathing in Ganyuan. Xihe may have been the sun god,
present at the very beginning. When Yao created an official
position responsible for surveying sun time for all places,
making calendars and setting standards for the four seasons, he
called it Xihe.

Great Western
Wastelands
大荒西经

Buzhou shan 不周山

西北海之外，大荒之隅，有山而不合，名曰
不周（负子），有两黄兽守之。有水曰寒暑之水。
水西有湿山，水东有幕山。有禹攻共工国山。

Beyond the Northwest Sea, in a corner of Dahuang, stood a
mountain that split down the middle and could not be fused
back together. It was named Buzhou shan, the "no longer whole
mountain." Legend has it that Gong Gong, the water god,
rammed into it and splintered the mountain when he lost a
fight to Zhurong, the fire god, to determine the ruler of heaven.
It was guarded by two yellow beasts. A river with hot and cold
water flowed down its two slopes.

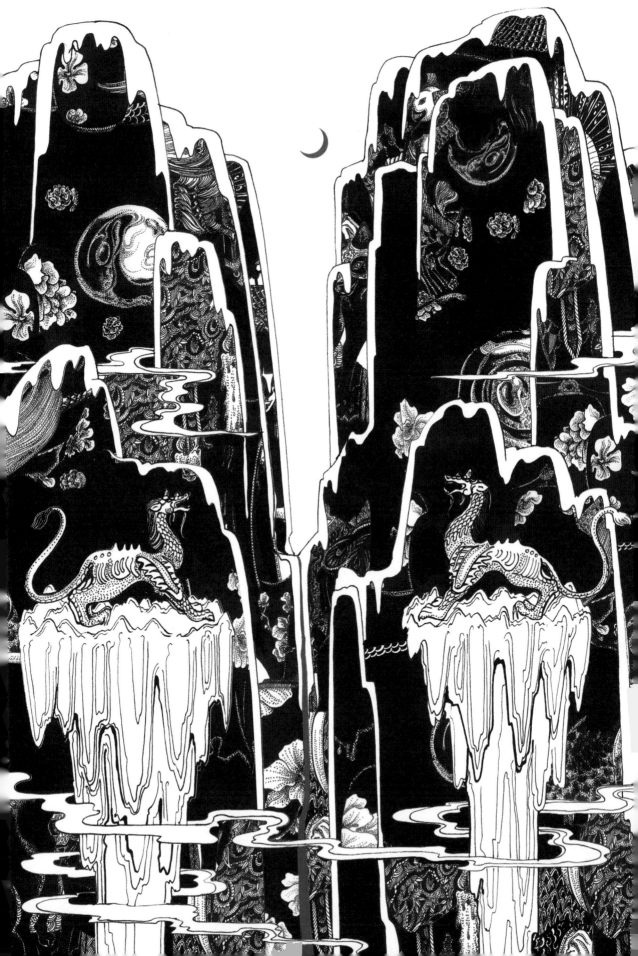

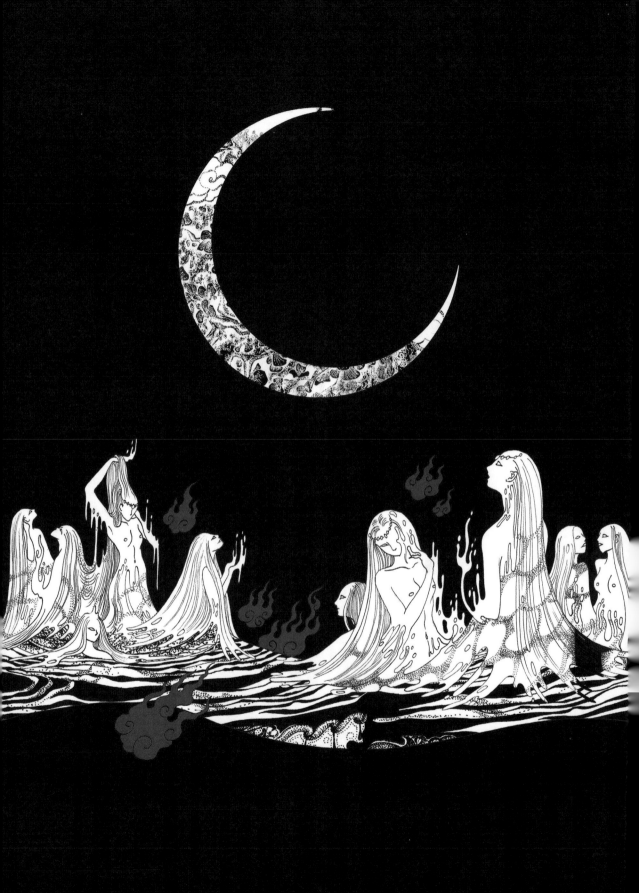

Nüwo zhi chang 女 蜗 之 肠

有神十人，名曰女娲之肠，化为神，处粟广之
野，横道而处。

Ten gods were named Nüwo zhi chang, all female deities who
were born from the intestines of Nüwo, the sister and then the
wife of Fuxi. They lived together by the roadside in the open
country of a place called Liguang and repopulated the earth
after disastrous wildfires and floods. She is often considered to
be the creator of all mankind.

Nüwo 女娲

女娲，古神女而帝者，人面蛇身，一日中七
十变。①

Nüwo was the most famous of all the female gods in antiquity and one of the original gods, whose greatest accomplishment was to create humans and patch heaven. She has been described as having a snake's body and a human face, though she could undergo seventy transformations in a single day.

Her image in Chinese society changed in correspondence with women's status; for the first six centuries of the common era, she was called "an ancient goddess" by scholars, but later historians of antiquity intentionally devalued her importance in Chinese civilization, linking her with Lü Zhi and Wu Zetian as women who tried to usurp power.

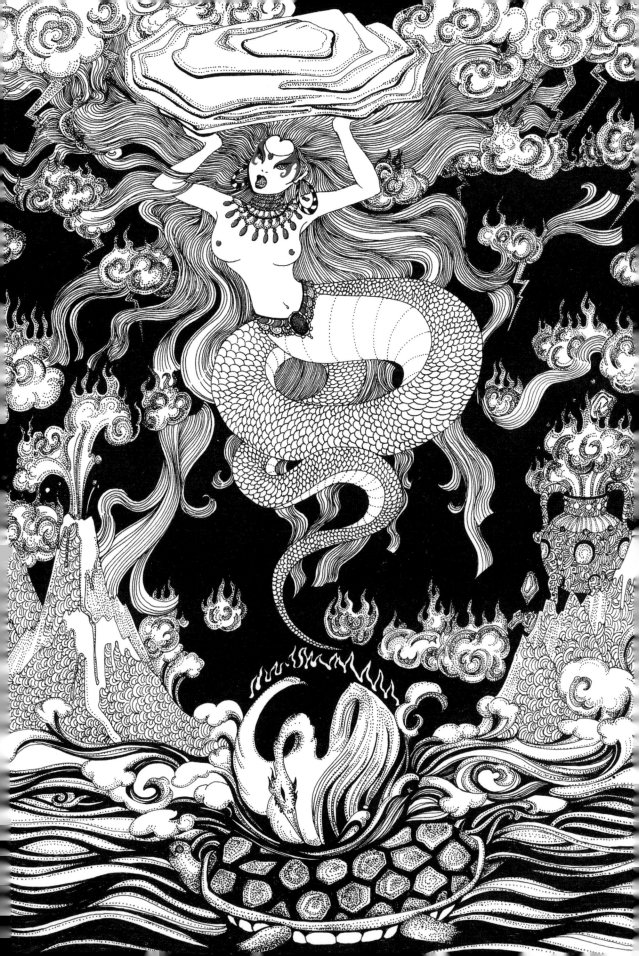

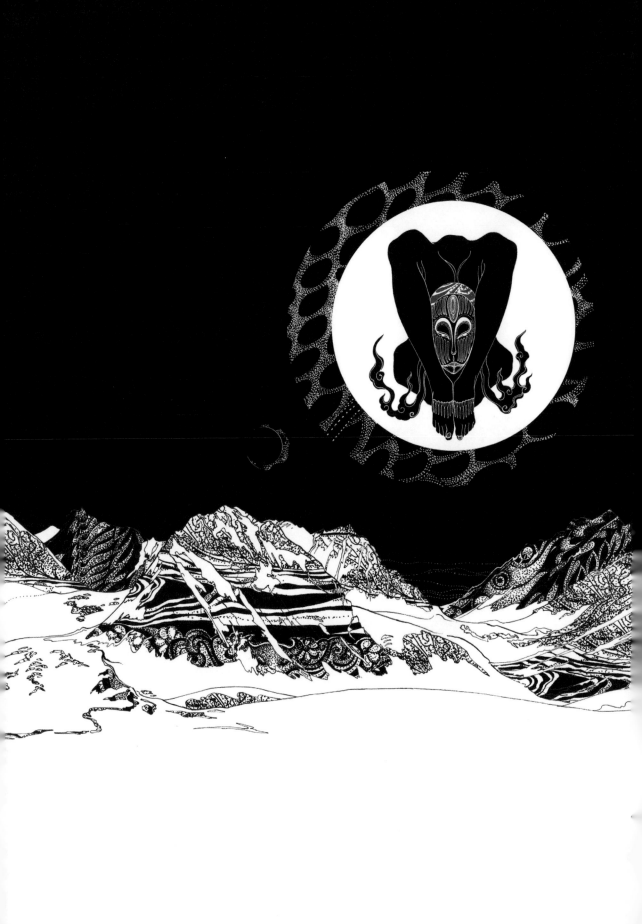

Riyue shan shenren Xu 日月山神人嘘

大荒之中，有山名曰日月山，天枢也。吴姖天
门，日月所入。有神，人面无臂，两足反属于头
上，名曰嘘。

There was a mountain called Riyue shan, or Sun and Moon
Mountain, which played a pivotal role in heaven. Its main peak,
Wuju Tianmen shan, was where the sun and moon set. A god
with a human face but no arms, and with legs that attached
to its head, was called Xu. It administered the timing of
movements of the sun, the moon, and stars.

Changxi 常羲

有女子方浴月。帝俊妻常羲，生月十有二，此
始浴之。

Changxi was a female deity and another of the wives of Dijun,
who bestowed the bow and arrow on the legendary archer Yi.
As the western counterpart of King Di's first wife, Xihe, who
gave birth to suns, she was said to have given birth to twelve
unique moon daughters. Here she is bathing them one by one
in a pool.

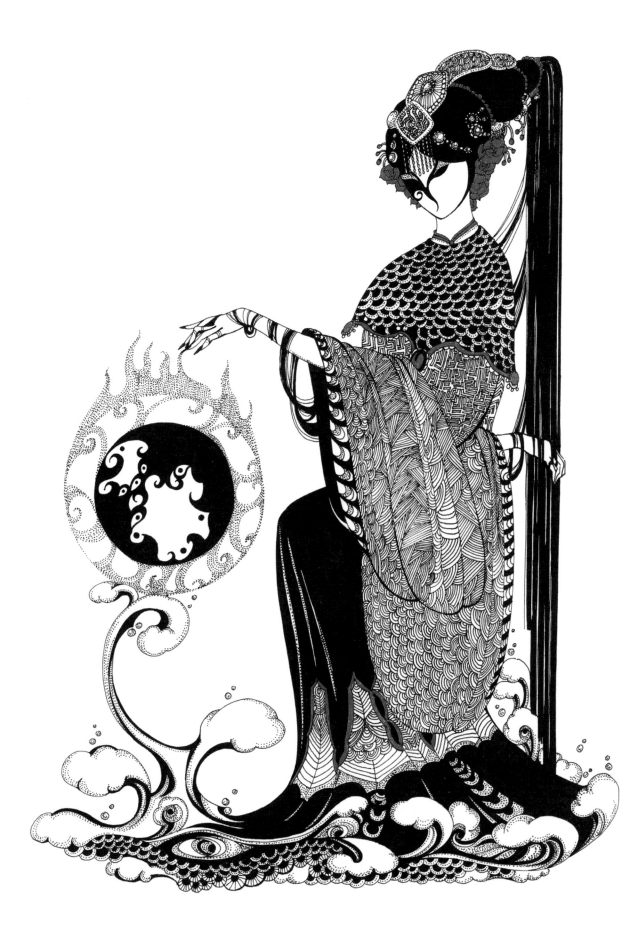

Great Northern Wastelands

大 荒 北 经

Jiufeng 九凤

大荒之中，有山名曰北极天柜，海水北注焉。
有神，九首人面鸟身，名曰九凤。

A god with nine heads dwelled on Beiji tiangui shan, where the ocean waters came from the north. Its faces were all human, all female, and all atop a bird's body. She was called Jiufeng, or Nine Phoenixes, and was a bird god revered by the people of ancient Chu. She was said by some to be a transformed giant oriole that snatched people's souls from them.

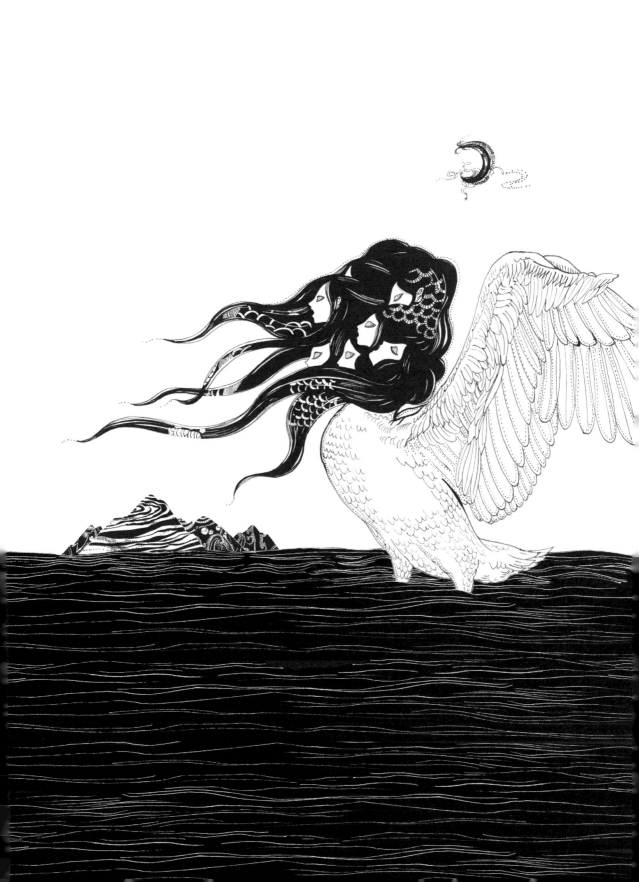

Ba 魃

有人衣青衣，名曰黄帝女魃。蚩尤作兵伐黄帝，黄帝乃令应龙攻之冀州之野。应龙畜水，蚩尤请风伯雨师，纵大风雨。黄帝乃下天女曰魃，雨止，遂杀蚩尤。魃不得复上，所居不雨。叔均言之帝，后置之赤水之北。叔均乃为田祖。魃时亡之。所欲逐之者，令曰："神北行！"先除水道，决通沟渎。

Back when the Yellow Emperor and Chiyou were in conflict, Chiyou fabricated many different weapons to attack the Yellow Emperor. The emperor sent Yinglong to the plains of Jizhou to fight off the attacker. He gathered up vast quantities of water, but Chiyou called for the gods of wind and rain to raise a violent storm that sent Yinglong into retreat. So the Yellow Emperor enlisted the help of his daughter, a Heavenly Maiden whose name was Ba, or Han Ba, which meant drought. She quickly stopped the rainstorm, creating an opportunity for the Yellow Emperor to kill Chiyou. But she was too exhausted to return to heaven and was given to roaming the human world, causing drought wherever she went. She was sent to the north, chaperoned by Tian Zu. She is depicted as wearing dark clothes.

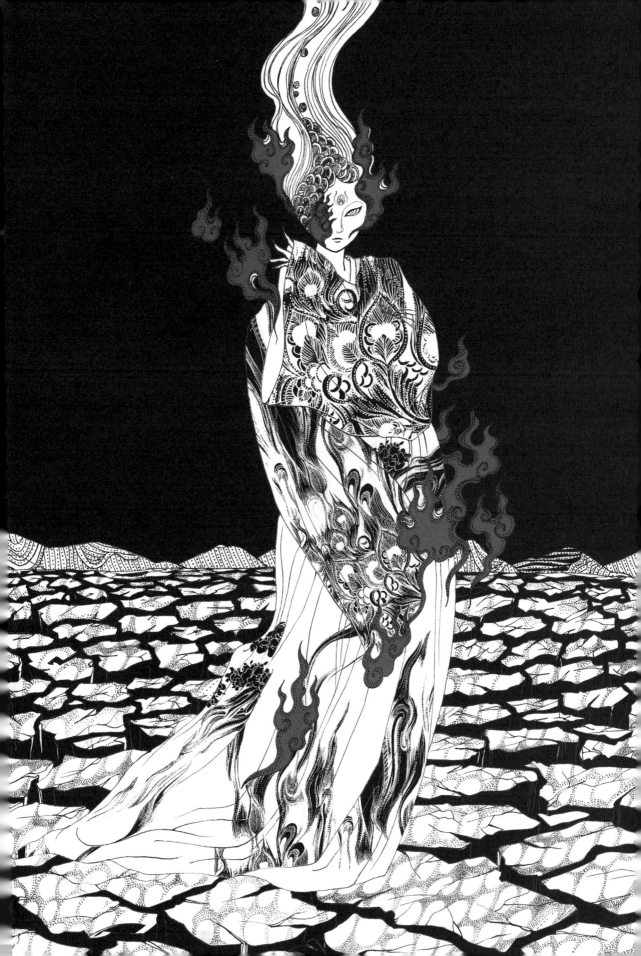

Lands Within the Seas

海 内 经

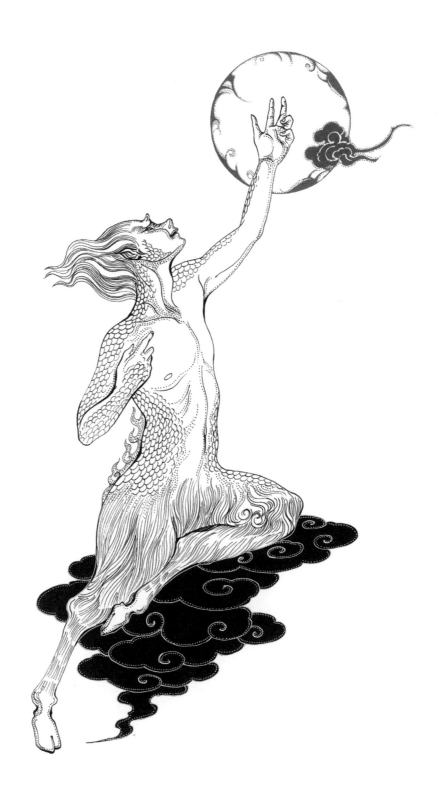

Han Liu 韩流

流沙之东，黑水之西，有朝云之国、司彘之
国。黄帝妻雷祖，生昌意，昌意降处若水，生
韩流。韩流擢首、谨耳、人面、豕喙、麟身、
渠股、豚止，取淖子曰阿女，生帝颛顼。

The Lands of Chaoyun and Sizhi were east of Liusha and west
of Heishui. The wife of the Yellow Emperor, Leizu, was the
mother of Changyi, who was exiled to Heishui as punishment
for an offense. There Changyi sired Han Liu, who had an
elongated head, small ears, a human face with a pig's snout, the
body of a Qilin, bowed legs, and the feet of a pig. He married a
tribeswoman, who gave birth to Zhuan Xu, great-grandson of
the Yellow Emperor.

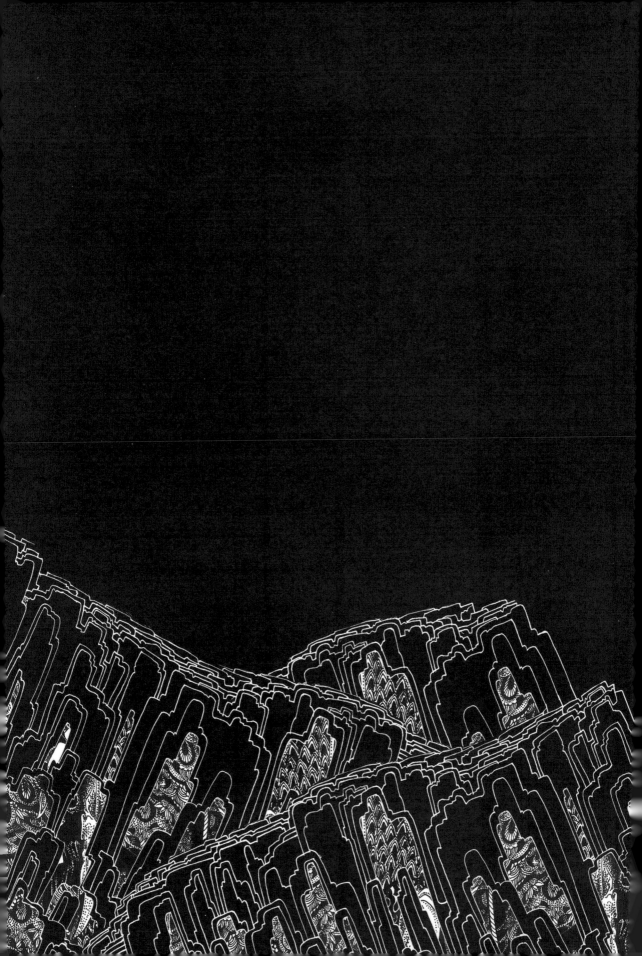

Gun zhishui 鲧治水

洪水滔天。鲧窃帝之息壤以堙洪水，不待帝命。
帝令祝融杀鲧于羽郊。鲧复生禹。帝乃命禹卒
布土以定九州。

During the time of devastating floods, without asking
permission from the Lord of Heaven, Gun stole his Xirang,
magical clay that grows and grows without stop, and used it
to build a levee to stem the flow of water. Outraged, the Lord
of Heaven sent the god Zhurong to the vicinity of Yu shan to
kill Gun. Three years after his death, Gun's body remained
intact and gave birth to Yu. The Lord of Heaven ordered Yu to
begin work to stem the flood, and when he did, he created the
Jiuzhou region.

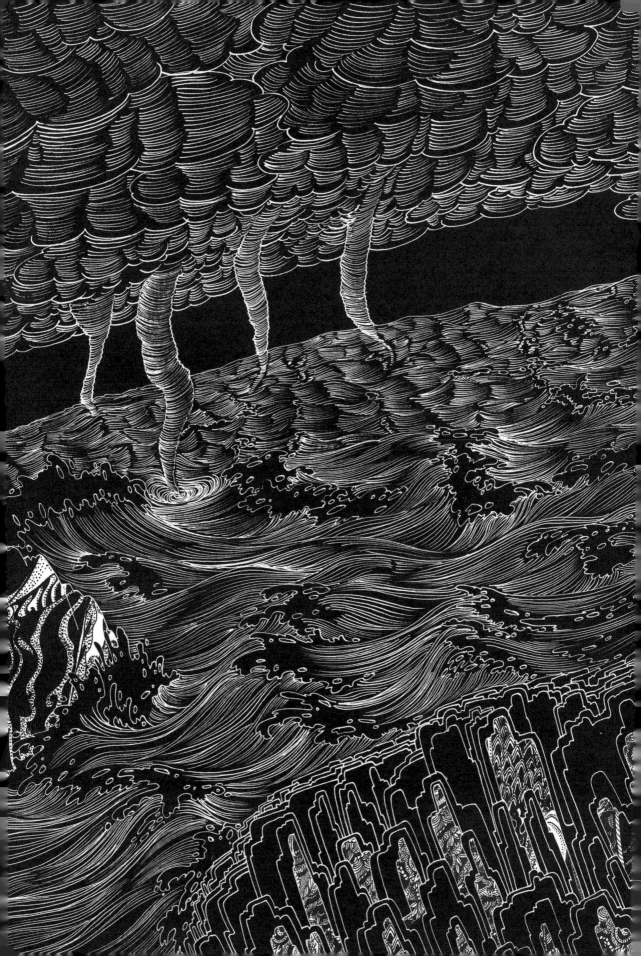

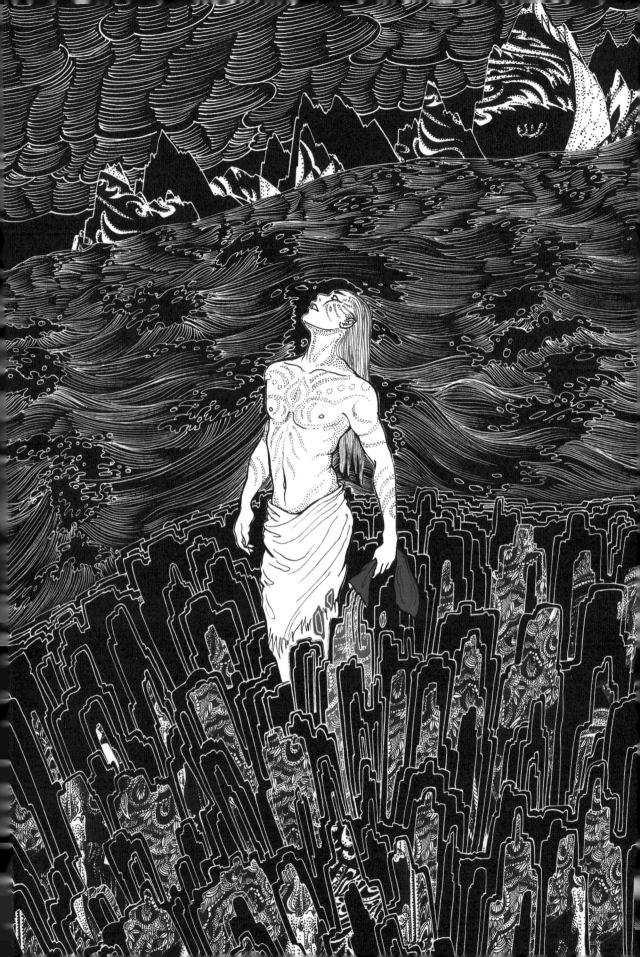

About the Contributors

Jiankun Sun, once known as the youngest "Genius of Chinese Cultural Studies," is now a graduate student at the Institute of History, Shanghai Academy of Social Sciences. He excels in research on *The Classic of Mountains and Seas (Shanhaijing)* and won first prize in Fudan University's Boya Cup national essay competition for his essay on it. He lives in Shanghai.

Siyu Chen, whose inspired illustrations provided the spark for this new edition, is a freelance illustrator. She graduated from Tsinghua University in Beijing with bachelor's and master's degrees, then studied illustration at the School of Visual Arts in New York City, where she received her second master's degree. Her published books include, besides *Fantastic Creatures of the Mountains and Seas (Shanhaijing)*, *Songs of the South (Chu Ci)*. Her illustrations have been selected for the American Illustration Archive. She lives in Germany with her husband and two children.

Howard Goldblatt is a literary translator of numerous works by contemporary Chinese authors, including Nobel Prize–winner Mo Yan, five of whose works are published by Arcade (*The Garlic Ballads*; *The Republic of Wine*; *Big Breasts and Wide Hips*; *Life and Death Are Wearing Me Out*; *Shifu, You'll Do Anything for a Laugh*). He has also translated works by Liu Zhenyun (*I Did Not Kill My Husband*; *The Cook, the Crook, and the Real Estate Tycoon*; *Remembering 1942*, which are published by Arcade), Huang Chunming (*The Taste of Apples*), and Chen Ruoxi (*The Execution of Mayor Yin*). He taught modern Chinese literature and culture for more than a quarter of a century. He lives in Lafayette, Colorado.